WHO WROTE THIS DAMN BOOK...?

Aubrey Malden is an award-winning copywriter, who has served up his creative genius in London, Brussels and Johannesburg. Amongst his 96 advertising and marketing awards are 4 British IPA Effectiveness Awards, The Gold American Effectiveness Award, and The Direct Marketing Effectiveness Award for Innovation and the only BAFTA to be awarded for a Television Commercial.

He has written for the marketing press, appeared on national TV and radio and having worked as a top Creative Director in three international advertising agencies and as a CEO in another International advertising agency in the UK, he is currently a partner at The Forensic Marketing Company and advises his clients on their strategies and executions to help develop their brands and deliver a better ROI. He also helps ad and media agencies pitch for new business, and has a staggering 75% success rate.

His best-selling first book, "Things the Brand Gurus Don't Want You To Know," is now in over 20 different countries and is used as a marketing bible by CEO's, advertising and marketing students, marketing directors, advertising executives and chairman of advertising agencies and marketing companies.

Other books by the Author

Things The Brand Gurus Don't Want You To Know

"A practical guide that will make and save you money..." **Wim van Melick,** *Ex-Member of the OgilvyOne, Worldwide Board and Director of Training*

ISBN • 978-0-620-43449-2

Published by

Aubrey Malden

(partner at Forensic Marketing)

33/35 Tate Crescent

Lonehill, Gauteng

South Africa

aubrey@forensic.co.za

Some names and events have been changed.

Photographs by Shutterstock, Thinkstock and Andre Erasmus of Kickstart, kickstartonline.co.za
Illustration on page 227 by Jenny Lamont

Designed by Sharné Edworthy • sharneedworthy@gmail.com
Typeset in Baskerville 10 pt

Thanks to proof readers and editors,
Barbara Cooke and Camilla Rankin, Camilla.rankin@tiswcali.co.za

Imprint; Printing and Binding by Creda Communications (Pty) Ltd

ISBN • 978-0-620-67626-7

Dedication

To my mother, Marie Malden.
Full of courage, curiosity, morality and fun.
Thank you and hugs.

BETWEEN THE BRIEFS

Aubrey Malden

TABLE OF CONTENTS

PREFACE BY JOHN TYLEE

"BETWEEN THE BRIEFS"

When I began writing for Campaign magazine, the London-based weekly bible of the advertising industry, more than a quarter of a century ago, it was still just possible to claim — and many did — that advertising was the most fun you could have while still keeping your clothes on. The outrageously camp creative director of one the UK's biggest agencies even challenged that popular notion by sending me a Christmas card with a picture of himself lying naked on a sheepskin rug with only a bottle of Bollinger protecting his modesty. I was immensely relieved to discover that I wasn't the sole recipient of this bit of seasonal goodwill to all men.

It's hard to imagine that stories like this — along with the ones that Aubrey Malden has to tell in this book — would be as plentiful today as they were back then. This was a time when advertising could still accommodate exasperating geniuses like Malden's one-time boss David Ogilvy. A man of compelling but also unswervingly hidebound views, Ogilvy was not a man who tolerated dissent — as Malden's story about Ogilvy, Paul McCartney and the soundtrack for a World Wildlife Fund commercial hilariously underlines.

This, and Malden's other tales hark back to a more freewheeling era in 'adland' when mobile phones were the size of breezeblocks, fax machines were as high-tech as it got and Sir Martin Sorrell's WPP was still making supermarket trolleys.

These are tales from the Seventies and early Eighties when British advertising still had some growing up to do. Of course, that rite of passage was a necessary one in which proper financial discipline had to be learned and credible management structures installed. Whether the business lost a lot of its sense of fun along the way will be the subject of perpetual debate. Malden's memories are the legacy of a time when the industry's old-class barriers were breaking down, heralding the arrival of a new breed of creatives united by their eagerness to explore new

ideas rather than their social backgrounds.

This new generation not only fizzed with exciting concepts but was also anti-establishment to the point of being downright subversive. Its members were overwhelmingly determined to enjoy themselves. The brightest and most rebellious of them were saved from the sack solely by their creative genius. Their bosses indulged them for what they could bring to the agency's profile, while clients were happy to stand back and let them work their magic.

Hardly surprising that this generation was such a fertile breeding ground for the kind of tales that appear in this book. And, talking of fertility, it's no surprise either that a lot of them involve sex.

In these more sober times, Malden and his contemporaries might be regarded by outsiders as little more than schoolboy pranksters – so say the tales of paper planes powered by fireworks and a toy tractor transformed into a dragster by a bunch of laid-back agency creatives with an oversupply of time on their hands! Sometimes the pranks themselves could be pretty creative and even sinister enough to leave their victims crushed.

What I think is probably the best such story — if that's the right description — fits neatly with those that form this book. It concerns the big-name creative director who appraised the portfolio of a young wannabe with his hand inside a Sooty glove puppet. "Well, I like it," the creative director remarked. "But Sooty thinks it's shit." Whether or not this story is funny or just plain evil will depend on how much your heart goes out to the young creative on the wrong end of such a brutal put-down.

Yet it's also worth remembering that out of the agency creative departments of the kind in which Malden worked — and where schadenfraude flourished — came some of the most iconic and

memorable advertising ever seen in Britain.

I love Malden's stories, not just because they make me laugh a lot, but also because they are precious and worth preserving. I can't imagine that, 30 years from today, those working in today's buttoned-down ad business, will have many similar anecdotes to tell.

John Tylee

Former associate editor of Campaign, the world's leading advertising magazine. He continues to write regularly for the magazine.

John Tylee, "These were the times when some of the most iconic and memorable advertising was created in Britain."

The Author

INTRODUCTION

When I started out on my journey in the advertising world it was the early 1970s and I had just turned twenty. I was still a very youthful, gangly kid. But I was lucky. I had the pleasure of entering the advertising world with two great friends whom I had studied with for three years, in one of the most stimulating and provocative environments in London: Ealing School of Art. It was a place filled with fun, and had more talent than any place had the right to hold onto. Pete Townsend of The Who strummed his guitar there and Queen's Freddie Mercury (the then shy and ever-conscious of his buckteeth, Ferrouk Bulsara) wandered the corridors, air-guitaring on an eighteen inch ruler, as he desperately sought out a band that would have him. After a succession of failed relationships with a few bands he formed his own, from the remnants of a band, called Smile.*

Fred, who became a friend of mine, went his own way, the art school couldn't hold onto him (he left before I graduated) and I went my own way a year later. Into my first agency in London, with my two close friends, Gregory and George. We were hired as a creative team of three, which was quite special. Indeed, I have never known this to happen ever before, or since.

The industry, to anyone who knows it, is hard. In it you'll meet impossible deadlines, subjective opinion, big egos, long nights (one agency I worked for had the unwritten motto, 'Work Hard, Sleep Fast') and many colleagues, some who become enemies whilst others become life-long friends.

This book is not about the long days or nights, or the techniques used to create advertisements, write briefs, or work out a strategy to win a new business pitch. It's about the facets of fun I've found between the briefs. It is, as the American legend of Madison Avenue, Jerry Delafemina, put it: 'The most fun you can have with your clothes on.'

Footnote: If you want a riveting and insightful read buy the excellent book by Mark Blake, "Is this The Real Life? The untold story of Queen."

"THE MOST FUN YOU CAN HAVE WITH YOUR CLOTHES ON."

Jerry Delafemina

The advertising business is, of course, a people business. It draws its talent from all walks of life. There are graduates of History, English Language and Chemistry, from Oxford and Cambridge. Graduates from Harvard and Drake universities in the States. There are ex-barristers, bus conductors and army officers — including one I met from the army intelligence corps, and another from the SAS.

Very few are snobs. Most are pretty earthy. Some highly egotistical.

Curiosity attracts them. Curious about the industry and curious about people, for to be in the industry you must have a love for people and the ability to engage and communicate with diverse target audiences when you are responsible for producing or approving advertising aimed at turning on the target audiences and influencing them in their purchasing decisions.

I loved meeting the curious people that litter the advertising industry and this book shares with you some of those memories. Some loves, some love/hates and some hysterical moments. You'll find a little sex, some stupidity from me, stubbornness from one of the greatest men I, and the advertising industry has ever known, and an adventure with a blow-up doll, amongst other things.

Enjoy.

Aubrey Malden
aubrey@forensic.co.za

THE EARLY DAYS

Chapter One

Binoculars.

They were essential equipment in an advertising agency. And particularly so in this advertising agency, at this particular time, lunchtime.

We were on the 3rd floor and George was 50 yards away, across the agency car park, in the recently refurbished mews flat that belonged to the long-legged Linda, a PA in the agency.

George had every right to be infatuated with Linda. She was the type of woman that looked beautiful even when she burped.

She was, like so many of those Seventies women, a convent teenager. A picture of innocence. Although she was as guilty as hell.

George was, as he said, "helping Linda put her kitchen shelves up".

He did this every Tuesday and Thursday. And every Tuesday and Thursday we fought over the binoculars to see George in action.

Word got round the agency and several of our colleagues joined us. We balanced precariously on the desk, or window ledge, fighting for a quick glimpse of George and Linda performing on the kitchen table.

But, somehow, word got round to George too, and the DIY stopped. In daylight anyway. And the binoculars were put away. For now.

This was our first job in advertising. Not peeking through binoculars, you'll understand, but as a team of three creative people working together on creating campaigns for the likes of Rover, Land Rover, Cadbury's, Outspan, International Wool Secretariat and The Sunday Telegraph.

We were known as 'The Three Wise Monkeys'. Not altogether a term of endearment. We worked hard enough and came up with some good campaigns, which seemed to annoy some of the more seasoned creative people in the agency.

THE MEWS WHERE LINDA WAS BANGED.

Egos in advertising were fragile things. Carbuncles, there to trip you up. Sooner or later you came across them and fell flat on your face.

Anyway, back to George and Linda. George was dabbling in danger. Dipping his pen in someone else's inkpot. For Linda was also having a little DIY with one of the senior executives of the agency. A man not to be crossed. A man who had the power to hire and fire. Such was our innocence we knew no fear and somehow George was oblivious to the danger.

Despite the fact that he followed Linda round the agency like a puppy, and met her in The Queen's Railway Tavern, in full view of the other *'Barry Bucknall', a senior executive in the agency, George never got caught with his trousers down, or up.

Perhaps it was something to do with the fact that he had such an angelically innocent face. How could this 'boy' of just 21 years of age, on a salary just good enough to buy a round of three half pints of shandy once a month, compete with a senior executive who had his own chauffeur, a salary big enough to buy a brewery and a pad, in and out of town?

How could he compete, after the senior executive quietly strolled into George's office one day and showed George the handgun he had stuck in the waistband of his executive trousers?

Still, it was fun while it lasted.

Like I said, egos were big in agencies. Pandering to them to create a pleasant working atmosphere was an art you learnt, early. Or didn't, as was the case with the 'Chairman's Cherub' – a fresh-faced trainee account executive, swollen with self-importance and a degree or two from Oxford. He was on the fast track, and things happened when he was around.

*

Footnote: Barry Bucknall was an English TV presenter who popularised Do It Yourself (DIY) on the BBC in the UK. The live show attracted 7 million viewers and, because it was live it often had Bucknall making some on-screen screw-ups, to which he would retort, "Well, that is how, not to do it!".

He appeared in my office at 9am on the nose. On his back one of those expensive suits from Saville Row. Bought by daddy, no doubt. It oozed cashmere with just a touch of silk. All the pin stripes were an immaculate match. In his hand a piece of copy, written by Tim, a senior writer, who shared the office with me.

"Tim in yet?"

This was a dumb question. Tim was a senior writer. Tim would arrive when he was ready, usually about 10.30. Then if you were lucky he'd fit in a little work before he lit his first joint, and then went for lunch at 11.30. Around 15 glasses of sherry in The Queen's Railway Tavern.

Tim was talented. He knew it, the creative director knew it, and all the awards' juries knew it. Hell, the whole of London knew it. The trouble was the 'Chairman's Cherub' didn't.

He went away and came back at precisely 10.30. And waited.

Tim strolled in at about 10.45. Took off his Afghan coat, you know – the ones that still stunk of a well-larded Afghan. The coat had the advantage of matching Tim's straggly hair and wispy beard. The complete ensemble was the fashion of the day.

We nicknamed Tim, 'The Goat', his bulging blue eyes helping to complete the woolly illusion.

"About this copy you wrote Tim," said the Cherub. "I've got some

suggestions I think you should consider."

Tim looked up from his green Remington typewriter. He lit a roll-up, sucked in the smoke slowly, and let it meander out.

"What am I?" asked Tim.

"A writer."

"What sort of writer?"

"A senior writer."

"What sort of senior writer?" Tim probed.

Silence. A slight tightening of the boy's buttocks.

"What sort of senior writer?" Tim repeated.

"Um...?"

"A fucking good senior writer? An award winning senior writer? A bloody good senior writer?"

"Yes."

"Well," said Tim, "this copy that you suggest needs changing, it can't be me then, can it? It must be this fucking typewriter."

With both hands, Tim grabbed the heavy Remington. Slowly and very deliberately, he picked it up off his desk and hurled it right through the closed office window. It landed, in a thousand pieces, on the busy London pavement below. Right next to a bus stop.

No one was injured. Not even Tim's pride. He put his coat on and went to The Queen's Railway Tavern to forget about it.

Tim never did get a Remington again. But at about 3.30 that afternoon

he did 'get' the trainee account executive, with a hot cup of coffee from the machine. Whipped with extra sugar, I think. It seemed to stick quite well to the cashmere and silk suit.

Music. Agencies were filled with music. Guitars were propped up in the corner of one or two rooms. They were essential bits of posing kit, irrespective of the fact that some of the owners couldn't strum the simplest of tunes.

The strangled tones were strummed-out, often accompanied by the pitter-patter of the drumbeat of fingers tapping on desks, or copies of the copywriters' Roget's Thesaurus.

Our office was different. There were no strangled tones. No inept drum beat. It was pretty harmonious, thanks to peer group pressure from an earlier period in our lives.

We were lucky. We'd spent the previous four years at an art school that had spat out pop groups that had actually made it to the top.

And ones that hadn't.

Our pop group hadn't. In all its various mutations. But we had been session musicians. We had played alongside some of the greats. And people had paid money to listen to us. One guy, in a church hall, got so carried away by the sound of The Sunsets that he put my lights out. He threw a Coke bottle that shattered on my skull. But, my beat went on, with the pat, pat of blood dripping from my forehead onto the snare drum.

Still we weren't that bad. I just think that he didn't like our particular rendition of 'The House of the Rising Sun'.

Our art school corridors had echoed to the sounds of Pete Townsend of The Who smashing his first guitar during his studies there. And, before that, to the musical pyrotechnics of the Bonzo Dog Do Da Band. The

Freddie Mercury (Farrokh Bulsara) studied with us. Leaving the course before he graduated, proclaiming, "I'm going to be a rock-star."

list of art students who mutated into rock stars in the 1960s was growing – Townsend, Ronnie Wood, Charlie Watts, Keith Richard, Jimmy Page, Eric Clapton – and now Freddie Mercury was on his way, although we didn't know it then, to mega stardom.

Freddie Mercury, of Queen fame (actually Farrokh Bulsara), had abandoned the Fashion Department on the second floor of the art school, where he studied with my brother Mark, and had migrated to the third floor where we studied advertising, marketing and design. The same floor that the pop groups came from.

I remember Freddie walking round the room with an 18-inch steel ruler in his hand mimicking Jimmy Hendrix. I remember him playing the piano in the Noisy Common Room. I remember, as head of the Union, booking his first band, as a favour, for a college 'do'. He wore a white suit that he'd knocked-up using his tailoring skills, learnt during his first and only year in the Fashion School. In those days the band was called Wreckage. I remember how we laughed when Fred lisped that he was going to leave 'to be a pop star'. Fred realised his ambition and we had realised ours. We hadn't made it into the music scene, but we had made it into advertising.

And now, we were in demand.

"We'd like you to form a band for the agency Christmas party" said the head of personnel.

After a lengthy discussion that lasted all of three minutes, we agreed. Especially, as someone pointed out, personnel were responsible for salary increases. And especially since, as George pointed out, the assistant in personnel was a bit of a cracker.

Besides, we were never sure, in those early days of our careers, that we would survive those preening egos, flying typewriters and coffee cups.

THE

LENGTHY

DISCUSSION LASTED ALL OF THREE MINUTES

If the band played well perhaps we'd have another career lined up, just in case.

Gregory, from the art school, would be on rhythm guitar. Geoff, an account manager, the lead guitar. And I would beat the skins.

"I hear you're looking for a bass guitarist?" said Doug, an account manager. The band was complete.

What Doug failed to mention in his short introduction was the rather important fact that he didn't actually own a bass guitar. In fact, he didn't actually own a guitar at all.

"Still, we could hire one, I suppose?"

"Of course we could. No problem," said George, who'd become the self-appointed manager of the band. He'd just nip down stairs to see the assistant in personnel.

About an hour later George returned triumphantly. He had persuaded the head of personnel to allow us to hire a bass guitar. So I got onto the phone immediately.

"Can I have a number, please?"

"Of course you can darling," came back the husky reply. Although I had the option of just pressing '9' for an outside line, I made a point of placing all my calls through Diana, the telephonist. We all did. We just loved listening to the treacley rich, Dietrich-like voice. She intrigued us. She was enigmatic and enchanting. All with very good reason.

She was, in fact, a bloke, formerly known as Adrian. No wonder the huskiness and the size 9 stiletto heels. At 6 feet 5 inches she had to stoop to board the tube train. We used to try and get our timing right, in the morning rush hour, just so we could see her.

Now she was in the bowels of the agency, manning, if that's the right word, one of the posts at the switchboard.

"I have your number, one moment please," said the honeyed, helpful voice.

I called the music store and ordered the Fender bass from one of those music shops off Shaftsbury Avenue, one of the many 'Aladdin Caves' hung with every conceivable guitar, and haunted by budding Jimmy Hendrixes, Eric Claptons and fading Hank Marvins. Gregory went to pick up the Fender and came back like a dog with two tails. Apart from hiring the Fender I think he tried every single guitar in the shop.

So, now rehearsals could begin.

We booked the boardroom and drew up a list of 30 or so numbers. A carefully balanced list. Slow smoochey jobs intermingled with ear-bracing, body pulsing numbers. Jumpin' Jack Flash, My Generation, Let's Spend the Night Together, Ruby Tuesday, the strutting Honky Tonk Women, Pain in My Heart, and the buttock bumping Come Together, tempered by Here Comes the Sun. We even risked displaying our full musical abilities by playing The Beach Boys' Good Vibrations, complete with flute and clarinet in the appropriate passages. We'd end, we decided, with The Stones' This Could Be the Last Time.

We should, of course, have realised why Doug didn't own a guitar. It wasn't, as he explained, because he'd had to sell it, because his wife had just had their first child. He couldn't actually play. Not very well, anyway.

Whilst Gregory's and Geoff's fingers danced over the strings and glided up and down the necks of their guitars, Doug's fingers sort of, well, tripped and stumbled at best, and at worst hovered like someone suffering from paralysis. An early case of Parkinson's, perhaps?

Gregory took Doug aside and very patiently, painfully tried to teach him

every single bass part. Doug picked himself up and stumbled on again. Tripping us up, as he went.

My god, time was running out.

Gregory switched his teaching methodology. Instead of giving the full bass part to Doug, with semi-quavers and quavers, where the fingers should tap dance over the strings, Gregory taught Doug to forget most of the 'twiddly bits' and just play crotchets, plinky-plonk style. "The way plonkers play," someone whispered under their breath.

Doug took the guitar home and practiced. He improved, a bit.

Doug made the Fender come to life - limping rather than running though.

Now he wasn't so much stumbling; more like walking with the aid of a Zimmer frame. Walking a little like a drunk, but walking nonetheless. One step at a time. Christ, how could his fingers miss those big fat bass strings spaced so wide apart? Doug did wear glasses though. Big, 'wise owl' spectacles, with a pound of glass for each lens.

We trimmed and cut our repertoire to accommodate the shortcomings and as we got a little more cohesive, we invited a selected audience to gauge our performance.

The girl from personnel arrived. She smiled. Even the head of the

agency popped his head round the door and was good enough to utter 'groovy' or some such word. And Doug said, "Cool, eh?"
Colleagues working late at night heard us rehearsing, visited the next day and made encouraging remarks: 'fab' and 'right on'.

We were ready. We had to be ready; the party was the following week.

The Railway Hotel had been booked. We'd made a trip to Take Six and bought the trendiest of clothes. The disco had been organised, along with one of those big back projection screens – the kind that old films could be projected onto, along with those coloured crystal slides, the ones that made patterns like mutating amoeba. Psychedelic images man, far out.

Pink Floyd's light shows would have nothing on this back-projected performance. As it turned out, they wouldn't.

Whoever it was who coined the phrase 'party animal' must have been to an advertising agency party. Come to think of it, Steven Spielberg must have been to an advertising agency party before he cast the folk for the bar scene in The Empire Strikes Back. Weirdos? They had nothing on us.

As soon as the doors opened, the staff started vacuuming up the drinks.

Whilst Public Relations people were famous for drinking gin and tonic we, in advertising, also made it our favourite tipple, along with Southern Comfort and Coke, Jack Daniels, Whiskey and American, neat Vodka, Vodka and orange, Brandy, Pernod and a drink brought back by those trendies lucky enough to go to posers paradise – The Cannes Film and Advertising Festival. The drink was a particularly lethal mixture of Pernod and Champagne. This complete cocktail of 'drinkies darlings' was washed down with pints of the head-banging Fuller's Extra Special Bitter and imported 'Pils' lager, where 'most of the sugar had turned to alcohol, you know.'

MOST OF THE SUGAR TURNS TO ALCOHOL, YOU KNOW.

Mineral water was for wimps; Perrier hadn't entered into our vocabularies in those days.

Tim, onto his second bottle of sherry by now, was surrounded by a familiar pungent haze. A Christmas joint fizzled in his hand.

We were scheduled to come on at 9pm. We reasoned that as the party started at 7pm, two hours would be about right for people to loosen up without the drink removing both bolts from their knees.

"People try to put us down…"

"Talkin' 'bout my generation," we crooned in chorus.

We'd decided to open with The Who number, My Generation. Something to get them bopping. And just as importantly, something Doug could play reasonably well. His amplifier was right behind my drum kit and I could hear every note thumping out. I was shocked. He was playing like a man possessed. My Generation had a particularly testing bass part and Doug had passed the test. His fingers were flying over the strings. We'd made a good decision. Start with the numbers that Doug feels happy with. Whilst his fingers were fresh, play the numbers with the twiddly bits.

Tim smiled at us. In fact, he smiled at everyone, so it could have been the mellowing effect of too much sherry and marijuana. Nevertheless, we took it as praise indeed, from one of the most cynical of seniors.

"Why don't you all f…f..fuck off!" sang Gregory, imitating Roger Daltry's alternative words to the song Generations. This went down well. A bit of disarming abuse and flagellation hurled at the audience. They loved it. Our hip chairman raised his eyebrows, encouragement indeed.

Even Tim stopped being overly cool for a split second.

Geoff and Gregory's arms swung like windmills mimicking, as best they could, Pete Townsend's lethal style of guitar playing.

The truth couldn't be denied, there would be no flying coke bottles that night.

I looked up. The dance floor was packed. Heads were turned towards us in admiration. George beamed from the back of the hall. The girl from Personnel was impressed, and so was the head of Personnel. Obviously our slick style of playing had vindicated her sanctioning the hiring of the bass guitar.

No one moved. We'd finished our first explosive number and they wanted more.

Flushed with success Gregory taunted the crowd.

"You think we look pretty good together?" He was singing the opening line from the next song, Substitute, by The Who.

You know the sound that your tummy makes when you're about to shit yourself? Well, I was hearing that gut wrenching sound now. An uncontrollable rumble, hardly noticeable at first, but there it was.
Was I was about to shit myself?

"Rumble woggle, dodum, dibble dibble, dum dum, wobble".

"Do dah, dibble dibble, dum dum gurgle do".

But it wasn't me. It was Doug. He had finally faltered. Doug wasn't even playing in the same parish as us. Whatever he was playing it had very little to do with the number we were now playing. Those uncontrollable rumbles were the sounds being punched out of Doug's bass amplifier, which was situated right behind me.

I reached to the right, groped for the volume switch and turned it down

a tad. Ah, that was better. The strangled tones were now being drowned out by the rest of the band.

After a bit Doug turned around and mouthed something to me, "Can you…?"

I shook my head and mouthed in return, "What?"

"I said can you …… me?"

"Whaat?"

"… can you hear me?"

"Yeees!" I nodded back in reply, smiling.

At the end of the number Doug looked very perplexed. I reassured him that the balance was perfect. Gregory reassured him too. Everything was just fine.

"I just need a little more volume so I can hear myself." Doug turned the volume up.

I turned it down again as soon as Doug's back was turned.

The same subversive scenario repeated itself during the last few numbers.

We ended with The Last Time, our favourite Rolling Stones number. Doug's bass notes barely audible under the slick sliding chords being strummed out by Gregory and Geoff.

We unplugged the guitars. I stepped down from my drum kit and collared Gregory.

"You know why Doug couldn't hear himself, don't you?" I said to Gregory, "I turned him down, it was so rough."

"You turned him down? So did I!" laughed Gregory.

We looked across at the bass amplifier, the volume control was left set on '2'. We'd started the evening with it set on '7', the ideal number of decibels for a Bill Wyman, or a John Entwhistle, but not for our fumbling Doug.

"You should see my knickers," invited Jane. We were at the bar getting well-earned pints to cool us down after our performance. And we were fishing for compliments.

"I said, you should see my knickers," repeated Jane. 'Praise indeed,' I thought. Jane was a curly haired red-head who worked in the media department. I'd been trying to get close to her for some months and had hoped that that night's performance by the band and, in particular, my performance on the drums, would impress her.

She was a little different to the other girls. She wore dungarees, which I loved. She was shy, demure and, as I'd thought, untouchable. Very little make-up, blue eyes as big as saucers, and boobs, well, boobs as big as you'd want. I'd been watching them dance around inside her dungarees during one of our numbers. During Maxwell's Silver Hammer, as I recall. 'Bang bang Maxwell's Silver Hammer came down upon his head'. 'Lovely little movers', I'd thought to myself.

My mind was wandering as I stood next to her. Transfixed by her boobs.

"You should see my knickers!" I came back to earth with a bump. Shy? Demure? Untouchable?

"OK," I said raising my eyebrows. "Show them to me."

She took my hand, hers still hot from the dancing, and led me over to a quiet and dimly lit area of the dance floor. Slowly she unbuttoned the side of her dungarees. And showed me her knickers: white with bizarre

blotches of pink staining.

"The dye's come out all over them, from my dungarees. I bought white dungarees and dyed them pink – all that hot dancing made the dye come out. The band was really good, thank you." And with that she zigzagged back across the dance floor disappearing into the throng.

'OK at least we'd talked, and she'd held my hand,' I consoled myself. 'I'd dance with her later'.

Jane's knickers were to become a bit of a novelty...

It was during one of the slower disco numbers that some of the staff stopped dancing. They were anchored to the floor their heads turned towards the big back-projected screen. Bemused, they pointed. Others stopped dancing and pointed too.

Jane stopped dancing with me and gaped at the screen. I tapped Gregory on the shoulder. Gregory stopped in his tracks.

Those at the bar stopped, in mid-drink, open-mouthed, they gawked.

Larger than life were two, 20 foot back-projected figures on screen, about to embrace.

The male silhouette was unmistakable. With that hooked nose and those wire-framed specs it could only be Joe Cohen, one of the directors. And when Joe got serious he took off his specs. In client meetings he took off his specs to make a point. The specs were coming off, this was a serious point.

Two hundred eyes focused on the other figure. Taller than Joe. Much taller than Joe.

Joe's python-like right arm slithered over the front of the dress, paused for a brief exploratory encounter and continued on over the shoulders, onto the top of the back and then onto the back of the neck, his hand drawing the two heads together. Their lips met as Joe's left hand made its way down, and then up the knee-length dress.

As one, we realised who Joe had in his arms. And what Joe now had in his left hand.

There was a loud grunt and at the same moment a deathly shriek from Joe.

It was Diana, the telephonist, and Joe had found his balls!

FIREWORKS

Chapter Two

All aboard. Next stop... meet Geraldine and the rockets.

"If we'd scored more goals than them we would have won."

"That penalty should not have been a penalty."

It was the usual talk on the Monday morning tube and Gregory and I had already skipped boarding one train so we could meet Geraldine, a temp from Essex, and travel in on the Metropolitan line, from Hammersmith to Paddington, with her. Traveling with Geraldine amused us. Her ready-made 'Coleman Balls' made us smile. We liked to hear her 'wases' as opposed to the correct and proper 'weres'.

"What did you do this weekend then Geraldine?" we goaded.

"Went down the pub with me mates, didn't I?"

She must have lived in the pub with her mates. Every Monday she told us that that's what she had done. "Gone to the pub with me mates." Nothing else apart from the bi-monthly excursion to see Queen's Park Rangers play soccer at Loftus Road in Shepherd's Bush.

"What you do then?" she'd enquire.

We explained what we'd been up to. Sometimes we embellished the story a bit, just so our lives didn't come across as too mundane.

"Oh was you?" came her reply. We'd crease up.

Occasionally we'd chuck in the odd 'was you?' and 'yes, we was' in reply to her questions, just so we could laugh again. She must have thought she was with a couple of pratts.

It's amazing the things you get up to shed the sheer boredom of traveling by tube.

Gregory did a great impression of an idiot. A village idiot, 'from Oxforrrrrdshire', traveling in to London to see the sights.

We'd be passing a huge scrap metal dealer at Goldhawk Road. The scrap consisted solely of cars, piled five or six high. Acres of them, wrecked, bumped and dumped.

"Here, they don't half park their cars funny in London, don't they?" Gregory would exclaim.

A few books and newspapers would be lowered by the passengers; they'd peer at Gregory. Sympathetically, they'd smile at me. Encouraged, Gregory would continue, head wobbling and gesticulating at the same scrapped cars.

"Got a lot of cars in London, haven't they?" Embarrassed sniggers would break out. Gregory would feign considerable upset, puff his cheeks out, dump his head on his hand and mope. He'd go silent for a few more stops.

"Are we still in London now, then?" he'd say quite loudly, so all could hear.

"Yep, we're still in London Gregory."

"Big place, London is then, isn't it?"

Yep, you could get really bored on the tube. And almost as equally bored at work, some days.

We'd been elevated to the building next door; our office was on the 15th floor. Up in the clouds. Looking out of the front window we had a fab view over Paddington Station complete with diesel haze that was constantly added to by coughing and spluttering British Rail engines. The view extended way beyond the Westway A40 and into infinity, on a good day. At the back, we could see a tiny corner of Hyde Park, if you leaned out far enough and wrenched your neck. If you looked down, you felt unwell. At least, I did.

Where the agency was, overlooking Paddington Station, and creating some beautiful thermals

Wooooooooosssssssh

This was a swelteringly hot summer in the Seventies. George had just had gliding lessons and apart from talking about the near misses he'd had and his proficiency as a pilot, he talked about 'thermals'. "Thermals would be pretty good", he suggested, "15 floors up".

A sheet of layout paper drifted out of our window. Gregory had taken up the challenge. The single sheet swung lazily from side to side, paused, dropped a bit and shot up, passing our window. Great thermals. It swung out over Eastbourne Terrace, spiraled down and then, swinging upwards a good 10 feet, it drifted its way onto Paddington Station roof. We turned away only to see George busily folding another A4 sheet into a simple paper plane. He launched it, the same thing happened, only better. Much better. Impressively better.

As the week developed, so did the designs. We had a 'Concorde' complete with drooping nose; it flew fast and furious and was tossed about in the breeze as it vectored in on the station roof. We had, with the aid of scissors and glue, a 'Spitfire', which folded itself in half and quickly descended to the pavement, directly below. We had wider winged planes with far more lift, that seemed to hang in the air like a hot air balloons. With the aid of our unlimited imaginations, a little experience from building model planes as boys and a book from the library, we had made ourselves our very own book of designs. About 20 in all. We placed bets on which designs would do well in which weather conditions. We got the stopwatch that we used to time our radio and TV scripts, and timed the flight times. We kept a record book.

And we argued. We argued about when and where the planes had actually landed because some of them traveled further than we could see. So, we brought in the binoculars. The very same ones that were

witnessing George exercising his cremaster muscle some months ago were now witnessing some of the longest flights known to man. Well, the longest flights known to us anyway.

41 minutes was the record. It landed over the other side of the Westway.

We got busy again with work, or we got bored flying the planes. I can't remember which came first. Besides no one was going to beat that record.

'Wooooooooooosssssh!' George and I looked up from our layout pads both busy with various campaigns. We gazed in disbelief at the windowsill, sparks and smoke trailing out of the opening.

Gregory's head turned towards us, wearing a very large and satisfied grin. Smug, that's the word. He looked very smug, as his head darted out of the window, following the last remnants of smoke.

George and I squeezed our heads out of the window to see something white and charred plummeting towards the road.

We hadn't noticed Gregory sneak into the office after his lunch. We hadn't noticed the small brown paper bag in his hand. Now he was opening it, grinning again. He dipped his hand into the bag and withdrew a small cardboard rocket. A firework rocket, the barrel bit no longer or thicker than your index finger.

"I got them from a shop in Praed Street." He withdrew another two.

He took a sheet of A4 layout and constructed one of the more basic dart-like paper planes. Breaking the 4-inch stick from the 'rocket bit' he carefully taped it into the belly of the plane. He pulled back his arm and without igniting the blue touch paper, he launched the plane across the room, testing it for balance. A couple of 'dry launches' later, and after shifting the 'rocket bit' around to correct the centre of gravity, he

moved over to the window. He placed 'mark 2' on the sill. We joined him, and then retired a safe distance as he ignited the blue touch paper and launched the plane.

The plane staggered under the weight. The paper fizzed a few angry sparks and then the powder caught. 'Woooooooooooossh!' Off it went, like a bat out of hell, propelling the plane straight out over the street. It was pretty spectacular, for three seconds at least. The powder exhausted, and with the belly of the plane smoldering, it dived uncontrollably into the street.

"Not bad, eh?" said Gregory, as he ducked in from the open window to prepare the last one from the paper bag.

There were others of course. Gregory had thrown down a challenge. Could we get one to fly further and longer than the 41-minute record of the rocketless planes, set at the end of August? This was the end of September and with it being Guy Fawkes time, there were plenty of rockets in the shops. Nearly six week's worth of rockets.

That shopkeeper in Praed Street must have had a great end to his year. We dutifully strolled up there practically every lunchtime for fresh supplies. Bags that normally transported rockets in threes soon swelled to six. Sometimes to twelve, when we skipped lunch, or when we got paid at the end of the month.

But you didn't have to be some whiz kid at British Aerospace, some white-coated, egg-head rocket scientist at NASA, to know we were up against it. Nothing to do with drag co-efficiency, the Bernoulli Effect, the theory of lift, nor some ex-Nazi's theory of thrust relativity, plundered from the archives of Hitler's bombproof bunker.

No sir. Just paper and payload. That was the problem. The rockets were too heavy for the flimsy paper wings.

So we switched to card. We increased the number of rockets too. Three under a wing. Four under a wing. We increased the size of the planes and made them out of A1 sheets. Big and impressive, and spectacular failures. Even when we suspended four more rockets under the fuselage, the result was the same. We tried two wings, bi-plane style. An extra canard wing. We added tail fins.

All had the same disastrous effect. A spectacular and explosive show 100 feet above Eastbourne Terrace, planes spinning and jerking in every direction as one by one the rockets fired. First, one under the right wing, then two under the left, then one below, jerking, pulling, pushing, twisting, turning. Then the finale, a crash into the street quickly followed by Gregory, George, or me picking up the offending evidence.

Some just spun in the air like an insane Catherine Wheel quickly drilling itself into the ground amongst a shower of sparks.

Dejected, we resorted to one rocket in a simple paper dart. They were fast and somewhat lighter on the pocket.

We found that if you rested the plane on the windowsill and let the rocket push the plane off you got a smoother launch. But you couldn't do this if you were aiming the plane across Eastbourne Terrace – directly across the road from our window. 'Rocket residue' (sparks and smoke) would threaten our office.

So, we launched the planes to run up the street, parallel to our offices. 'Woooooooosh!' Off they'd go hugging the exterior walls and glass-paneled building. This was, of course, great fun, particularly as you ran the risk of waking someone in their office after a good lunch.

"David says could you please stop the planes for the next hour, and then come and see him," said Sue. She was a PA who inhabited one of the inner offices down the corridor from us. Her office ran parallel to our

present flight path. Being an inner office she had no windows, but her boss had the office with the windows. He was the Managing Director of our division. He was our boss. Our big boss. He was making a very important presentation to a client of the agency.

It turned out that David was presenting his proposals with his back to the window. The client was obviously looking directly at David, and therefore had a reasonable view of the window.

"Thank you for being with us today, a very important and visionary day. A day when….."

'Wooooooooosssh!'

Somewhat startled, I would suggest, the client's gaze moved from the flip-chart David was presenting from and followed something flashing past the window.

"Um, as I was saying, this is an important day and the creative team has been burning the midnight oil to come up with something quite extraordinary…"

'Woooooooossh!'

The client's attention wandered again. His neck jerking from left to right, as quickly as a whippet could run.

David must have hesitated at this stage but he was not one to be put off. He was ex-army and used to being under fire.

"Our strategy is a two-pronged approach. We'll attack the competition by rolling out a cracking promotion backed up by a sustained period of hard-to-miss advertising. As you're about to witness the campaign is particularly impactful and …."

'Woooooooosh, psssst, ffffffffffst!'

Apparently it was this one that actually glanced off David's window and died in a show of sparks. Sue was summoned by David and enquiries commenced. Two more planes later led Sue to our office.

"He's not best pleased," she said, in her best matron's voice.

"Do that again," said David, "and I'll break your bloody nose."

All we could manage was 'sorry'. We kept on saying 'sorry, sorry', when really what we wanted to say was something like, 'Oh great one, one who has the power of employment over us, forgive this thoughtless act. We are mere morons honoured to be working you. Our bodies are a waste of skin. We thank you for the gin and tonics you've bought us in The Queen's Railway Tavern, and apologise for only managing to buy you, in return, a half pint of bitter. Please remember the times when we've worked weekends for you. When we've come in at five in the morning to do your work. We wish you well. We wish your family well. We wish your horse well. We wish your

enemies harm, may they
roast over a hot fire never to cross you
again. May the M4 to Maidenhead never be choked with traffic when you need to get home. Please, oh please, may your retribution only be verbal'.

Amidst all these thoughts I heard the occasional 'thoughtless … juvenile … pathetic … shouldn't be employed in a kindergarten', punctuated by 'bloody noses'.

After we'd finished apologising, David lit a cigar. The client liked being in an agency where things happened. Where a bit of creative pyrotechnics went on, I suppose. And the client had a good story to take back to the factory. And some good work, which he'd approved.

Some months later David would ask us to be part of a new agency he was starting. We liked David a lot.

David seemed to understand us. He even understood us to the point where he asked us to check if he was in, before we flew any more planes.

I can't remember who heard the fire-engine approach the station. Who lifted the window and saw the station roof smoldering. I'd like to think it wasn't us that were responsible. Perhaps it was a spark from one of the engines? On the other hand, did diesel engines make sparks? Rockets certainly did. Particularly that last one we let off.

And it flew rather well too, straight onto the station roof. Beautiful thermals.

THE TRACTOR

Chapter Three

We'd become known as 'The Three Wise Monkeys', more for our mischief than our wisdom and it was reasonably well founded.

"Err, hum, hum, hum agh ha." A sound that mimicked that of an old 1928 Model-A Ford straining to start – after many hesitant whirrs of, 'hum, hum, hum…' finally coming to life and then backfiring with an, 'agh ha!' This was, in fact the rasping sound of Cliff Buttery clearing his throat of phlegm and, in doing so, mimicking, remarkably closely, the sound made by a 1928 Ford trying to start. Phlegm induced by many years of sucking on 'The Cigarette that Satisfies,' Senior Service, un-tipped.

Cliff, unfortunately for himself (and for us), thought he was our boss. Now Cliff absolutely wasn't, but no one had bothered to tell him that, least of all the god of the agency, Mike Savino, Creative Director. Somehow, agencies back then weren't that good at internal communications nor management techniques (indeed, how good are they at it today?).

Consequently no one had told Cliff, who had the inner office from ours, that the superior geographical location of his office (he had a street view, we didn't) didn't automatically give him control of those in the outer office, which was us.

Neither did age give him control. Cliff was born, perhaps appropriately enough, about the same time as the 1928 Ford Model-A he often mimicked, and we weren't made at that time. We were part of the Swinging Sixties and Seventies. Part of the new set. Arrogant and young and along with it quite ignorant of office politics and, sadly, somewhat, though not always, oblivious of peoples' feelings. We wore pink shirts and bollock-crushing blue velvet trousers. Cliff's shirt was white, his baggy trousers grey. Our hair was backcombed or wildly curly, like an untamed Busby. Cliff's was short, smooth, with a parting and was heavily tamed by a barrel of Brylcreem.

"Err hum, I want you to look at this for me, boys." Cliff was attempting to brief us on a project; as I recall, it was for Walls meats.

"Love to do it," said one of us. "But," added another "we're too busy on other stuff."

"But I want you to do it," insisted Cliff.

"But," said one of us continuing, "you are not our boss."

*We became known as **The Three Wise Monkey's**. In retrospect calling us 'monkeys' was right.*

Defeated, Cliff turned on his heels and went into his inner sanctum, pulling the door firmly shut. Not a slam, just a firm pull. He was too much of a gentleman to slam the door. But he was pissed off.

There were several other attempts from Cliff to gain control of 'The Three Wise Monkeys'. All rebuffed by, "Too busy on other stuff" and "Got to do a job for Mike (Savino)" and "Have to go to a client meeting" and, sometimes, "Got to go to some focus groups."

To be fair all of them were true, to a certain extent. At least they were certainly founded on truth. Like when we said, "Got to go to a client meeting", we did have to go to a client meeting, but we didn't actually have to go that afternoon, so we could have fitted the job in for Cliff.

When we said, "Got to do a job for Mike", what we actually meant was we were going to ask Mike for some work so we didn't have to do anything for Cliff. And, after all, Mike was actually our boss. Mike had hired us and told us we reported directly to him and no one else. We found this hard to tell Cliff, and it certainly shouldn't have been our place, as juniors, to tell him. Mike should have told him.

We told Mike what had been going on and Mike said, in his soft Los Angles accent, which went with his soft droopy eyelids, probably heavy from smoking grass, which in turn seemed to have smoked his complexion a soft Latino brown, "Hey, stay cool guys, stay cool. Cliff has just been put over there to graze man. I'm in charge of you guys. Hey, relax guys, take no notice. Don't worry, I'll speak to him."

And of course, Mike didn't.

So on it went, with Cliff eventually trying to befriend us. The clubs he went to weren't the clubs we inhabited. The 'RAF Club' wasn't exactly the same as 'The Marquee Club' in Wardour Street, or that one in King's Road, whose name escapes me now, the one where the ultraviolet light lit up all the women's underwear (assuming they had underwear on, that is).

Cliff, I recall, lived outside London, in Norfolk. Norfolk is where turkeys come from. We, and the creative department, lived in Chelsea, Kensington, Chiswick, Shepherds Bush, Mayfair, Knightsbridge. The places where the night owls roosted when they weren't out playing in the late night, pot-filled clubs.

"Err, hum, hum, hum." It was Cliff and he was standing in the entrance to our office.

"Agha ha!" he cleared his throat: "I was given this at lunch time and wondered, err agha," he cleared his throat again, "if you boys would like it?"

It was a big cardboard box about the size of one of those boxes removal men use. Too big for Cliff, who was grasping it from behind with his two hands supporting the front of the box, just. His face peaked over the top of the box; he looked slightly embarrassed as he set it down with a solid 'clunk' on Gregory's desk.

George took a Stanley knife and started to slit open the brown tape that was sealing the boxes' top flaps. He dipped his hands in and they came out clutching a huge tin tractor.

It seemed a little odd to have a large tin tractor in a London advertising agency. The tractor would have been more at home in well, yes, Norfolk, or perhaps, closer to home, Harrods Toy Department. It was magnificent and certainly would have commanded a Harrods price tag. It was beautifully finished. Big fat rear rubber tyres, with treads that could grip anything from an Axminster carpet to a well-grassed football pitch, or backyard garden with lavender, roses and soft green lawns with a ha ha. The side's bodywork, although straight tin and not embossed to simulate the engine, were precisely painted to show practically every detail of the engine and any visible gearing. The seat was a big black saddle-shaped one, almost the size of the palm of your hand. It had no farmer astride it but it was, although driverless, quite perfect, apart from two incongruous additions.

It had two big fat bumpers, one front and one rear. Turning it over we noticed a large clockwork motor that drove the tractor with a huge and powerful-coiled spring.

"Thank-you Cliff," said George, very politely, as he continued to take things out of the box.

Cliff, in surprise at George's thank-you, raised his

Cliff asked if we would like what was inside the rather large box. Of course we did. It looked like fun.

eyebrows as high as a ventriloquist doll and went into his office and quietly closed the door. Did I detect a little shake of the head and a stifled and triumphant smile? I think I did.

George pulled out the instructions and a massive key; he searched for the keyhole, which was just down from the driver's seat. He inserted the key and read from the instructions, "This is a push-pull friction activated tractor." What that meant was if the tractor banged into something going forward, the fat front bumper would click backwards and that in turn would send the wind-up motor into reverse gear, sending the tractor from forwards into reverse. Conversely, when the tractor hit something behind it, the fat bumper at the back would trip the gears into driving the tractor forwards.

We positioned the tractor between two of our desks and set it gently chugging and bumping to and fro between the two desks.

This, as you can imagine, got quite boring very quickly, so we took it out into the corridor and set it running between the opposite walls in the corridor. Eventually this got quite boring too (not to mention quite annoying for the inhabitants of the offices, for the tractor was no lightweight and made quite a substantial 'bonk, bonk' as it hit the two sides of the corridor in question).

So, with new found vigour, and a sense of purpose, we continued to test the abilities of the tractor on the open road as it were, by running it down the length of the corridor. How fast could it cover twenty feet on carpet, twenty feet on cardboard? Could it climb a slope of cardboard? If so, what was its ceiling? Tilted at ten degrees, then thirty and so on, until finally the tractor could grip no further and just spun its rear tyres on the cardboard, then running out of spring power it would slide down the card to the floor.

In between our various comprehensive and exhaustive test drives,

Cliff would step out of his office, give the tractor a quick glance and us a resigned look of something...pity? Exasperation? Shame? But, in retrospect, I do think he was thankful too. Thankful that he had made us grateful to him, for something that, at last, had somehow, and probably totally accidentally, found common ground between us.

And it was a ground that we were to plough frequently. In fact, whenever we needed a moment of repose, or wanted to relax our brains to enable us to find a creative idea, we got the tractor out. The iconic David Ogilvy recommended a glass of wine to relax to; we recommended the gentle hypnotic 'tock tock' of a big toy tractor as its spring slowly and inexorably unwound, sending it in a tortoise-like manner down the corridor. Slow and determined.

But eventually the monotony of the slow 'tock tock' and 'thud' as it reversed and then the 'thud' as it went forwards again, became mixed with a sense of adventure; curiosity got the better of us.

"I wonder how fast this tractor could really go?" said George. "I mean, if we took the governor out of that motor, how fast would it go? It's got a massive spring."

So, George got the handle of a scalpel (minus blade, of course) and, with some difficulty, levered out the governing flywheel with a 'ping!'

The noise caught Cliff's attention as he strolled down the corridor to the gents. He turned and raised his big black bushy eyebrows, disapprovingly.

George inserted the key through the hole in the exquisitely painted bodywork and turned it, coiling the massive spring fully tight as he did so. He turned the tractor over, so we could see the underside and then released the little slide brake.

George released the true potential of the tractor by setting free its massive spring.
The recoil was, spectacular, and yet horrifying, for some.

'Whiiiiiiiiiiiiiiiiiiiiiiiiz!' The rear wheels spun around like a hamster's wheel driven by a hamster on a heavy overdose of amphetamines. It was very impressive.

George rewound the key and set the 're-tuned' tractor on the carpet in the corridor.

He released the brake and the tractor shot down the corridor, banged into the wall and reversed back towards us, slowly stopping just before it made it back to us, as the big spring had exhausted its power.

George recovered the tractor and rewound the spring. He set the tractor down again, this time sighting it from behind to make sure it would have a clear run to the end of the corridor, I guess a run of some fifty feet.

Then: 'Whiiz.' Off it went like a bat out of hell until 'clunk!', it hit an obstacle, Cliff's shoe. The tractor paused for a millisecond as it found its reverse gear against Cliff's polished K Shoe (Lonsdale style) and then 'Whizzz', it began its return journey home to us, but ran out of steam as before, stopping in no-man's land, halfway between Cliff and us.

George, head bowed, sheepishly sauntered forward to pick it up. Aghast, and without comment, Cliff stepped over the tractor (and George, who was bending down to pick it up) and returned to his office. He closed the door a little more firmly than before.

We put the tractor in its box and got back to work.

A hectic period of work hit us and some late nights too. We had no reason to bring the tractor out as we went through a purple patch and weren't stuck for ideas. Indeed, I remember it was quite a productive period, including a pitch for the Cadbury business, which we won.

On top of this, we also felt a little remorseful because of the speeding

tractor incident in the corridor and, in addition, we did feel further for Cliff because of the fact that Mike wouldn't grasp the nettle and tell Cliff he wasn't our boss.

I can't remember how it started again. Boredom? Stuck for an idea? Generally annoyed and frustrated that Mike still hadn't spoken to Cliff? No exciting briefs? A rainy lunchtime? Who knows?

Anyway, it started again, and this time it was a period of further customization. Radical customisation.

"If a tractor goes that fast without the governor, imagine how fast it would go if we…?" mused George.

"…took off some of the bodywork to lighten the load?" I suggested.

"…stripped it right down?" said Gregory.

"Exactly!" George replied.

We set to work with our scalpels and Stanley knives. Removing anything that gave it the encumbrance of weight and poor aerodynamics which, in essence, meant that all the beautiful bodywork was removed.

We ended-up with, well, basically, a chassis, a large clockwork motor with a prominent and massive spring, two huge tractor wheels at the back and two tallish thin wheels at the front, an incongruous exhaust stack and a black saddle seat poking out of the modified machine.

It whizzed down the corridor all right but it didn't look the part, so we managed to hack off the exhaust stack and the saddle seat. It looked better, but still not the part.

I can't remember who had the idea but it was radical and, as it was the way the design was heading anyhow, it was going to be just right for the job.

We removed the front wheels and put them to one side. Inserted an eighteen-inch plastic ruler, flat side up, under the wheel-less front axle, secured the ruler firmly to the chassis with a mixture of double-sided and masking tapes, then made a new front axle from a small bit of rod we procured from an old Meccano set. We mounted the wheels right at the front of the new eighteen-inch ruler protrusion, sealing the ends of the new axle with some small plastic tubing. And she was ready to go.

The tractor was re-born as a very long dragster. And boy did she go! The back wheels gave huge grip to the lightened front load, momentarily lifting the front wheels off the carpet before she hurtled down the full length of the corridor slamming into the lift door (thank goodness it was closed) at the far end.

Future runs had one of us guarding the lift doors. If they opened, a foot would stop it hurtling into the lift. We even toyed with the idea of connecting the front bumper again so that, should it hit something, like the back of the lift, it would go into reverse. In the meantime, the lift doors would close, and the tractor/dragster would be encaged, so it would hit the doors of the now closed lift, go forward again, hit the back of the lift again (all while the lift descended), then it would hit the front of the lift, then the back again and finally, if the timing was right, and if it hadn't run out of power, it would, as the lift doors finally opened on the ground floor, shoot out of the doors and race across the polished marble floor towards Jenny, the blond who manned reception, and would then come to rest at her teak desk.

Arriving with a gentle 'thud!' it would, we guessed, be quite a sight to behold and certainly turn the heads of those clients seated in reception.

But for some reason, probably the fear of losing our jobs, we didn't behold it. Instead, we raced the tractor/dragster down the corridor a few times, actually to the delight of some of the few who inhabited that

floor, excluding Cliff, of course.

Then we got bored. Not with the work, but the tractor/dragster, so we put it away.

"We haven't tried jumping it, though, have we?" said one of us, one lunchtime.

"Doing an Evel Knievel, you mean?" said another.

And so, we embarked on an expedition to the agency's art stores, in the basement of the agency, where all the stationary for the creative department was kept. There were rulers (we took a little six inch one), pens, Magic Markers, scalpels, Stanley knives, Sellotape (we already had some) but we didn't have any two-inch wide masking tape, so we took a roll of that, and a roll of 'D.S.' (double-sided tape). There were layout pads in A4, A3, A2; tracing pads, also in A2, A3, and A4, and cardboard in huge A1 pieces. We took eight sheets.

"Eight sheets!" exclaimed Stan, the ex-military man with pencil thin moustache who ran 'his' tightly controlled stores.

"Got a big job on, Stan," I said as Gregory and I slid the eight sheets (four sheets each) as best as we could under our arms and trudged off upstairs, via the staircase and lift, with our spoils.

George took a minor detour and veered off to the 'Dispatch Department' to procure other much needed material.

It was still lunchtime when we removed the long eighteen-inch ruler from the tractor/dragster's front end and attached the short six-inch ruler instead, complete with the wheels and axle – which we had removed from the eighteen-inch ruler earlier.

Gregory and I moved two of our desks further apart and put a sheet

Cliff's neat row of soldier-like Magic Markers would soon be destroyed.

of card on each desk leaving a gap, of about two feet, between the two sheets.

I wound up the — I don't know what I would call it now: the 'leaping ex-tractor', I guess — and placed it at the back of the sheet of card on my desk and let her go. 'Wizzzzzz, Weeeeeeeeeeee, clunk, wizzzzz, weee, thud!' The leaping ex-tractor raced across the card on my desk, leaped the two-foot gap between the two sheets of card with no bother, landed on the card on Gregory's desk and raced off the end of the card, leapt into the air for a short period, say another couple of feet, and banged into the wall with a thud. All 'easy-peasy!'

We'd have to find something more challenging.

If Cliff had been our boss and if we had wanted to be fired by him, this next moment would have been the ideal set-up. It was a moment of thoughtless insanity.

We looked for a bigger gap to jump the tractor, and we found it one lunch time while Cliff was out. There it was staring us in the face: don't make the tractor leap laterally anymore, confined by the width of our room, make it leap lengthways along the length of our room. Better still, open Cliff's door and make it leap from a re-maneuvered desk in our office to Cliff's large oak desk that was set back a good five feet inside his door.

We built a ramp of card from the floor that ran up onto my desk, we then continued the runway with a new length of card across my desk (stuck together with a strip of three-inch wide masking tape), then we left a gap of about four feet and built a runway from the other direction, from the top of Cliff's desk to line-up and meet the runway from my desk (leaving a four-foot gap in between). A bit like a river swing-bridge leaves a gap, open in the middle, for the tall-masted ships to sail through. Except this was for the tractor to sail through. A little less graciously and

in the air, of course. At least we hoped so.

And it did. Beautifully.

Having climbed the ramp on my desk, it sped across the flat runway on my desk then leapt, wheels whirring and whizzing in mid-air, landing on the runway with a hefty thump on Cliff's desk and immediately, as the tyres bit into the card it skewed off, drunkenly to the left, leaving the confines of the cardboard runway that we had carefully placed and taped upon Cliff's desk. In an ill-disciplined lurch it hurtled into the pot of Cliff's freshly sharpened pencils and pens of many colours, which he kept tidily on his desk, it knocked the pot over, spilling the entire contents with an initial clash, then a clatter onto his desk and floor. The pot gently rolled to the side of the desk, teetered for a split second, then arrived with a hollow 'bonk' onto the floor. The tractor pushed its way through a pile of papers, scattering them as it went, banged into a box of paperclips unshipping them and sending them strewing in every direction, it pushed Cliff's open diary onto the floor and finally, it thudded into the upholstered back of Cliff's executive chair bouncing, upside down onto the chair's padded seat, the tractors' wheels still hectically spinning and thrashing in thin air like some large dung beetle trying to gain traction and right itself.

We looked at the mess and destruction.

"Oh shit," I would have said if I had had the time. But I didn't. There was a cough and a splutter and, behind us, stood Cliff. He stood motionless, just for a split second, as he surveyed the debris on his usually tidy desk, the rearrangement of his furniture, the part-blockade of cardboard into his office, and then he turned on his heels and left.

He marched down the corridor, punched the lift button and when the doors opened he disappeared.

Straight into Mike's office. Cliff asked to have us fired. Mike simply moved us out of Cliff's grasp, and out of harm's way, into a new inner office. An office with a view.

Cliff left the agency a short time after the flying tractor incident and I often wondered what happened to him. It was a few months later when my mother said, "Was that man Cliff, the one you told me about dear, called Cliff Butler?"

"Yes Mum."

"Well, I've heard some plays on radio written by a man of that name and they are jolly good too!"

KNOCK SOFTLY, BUT FIRMLY, WE LIKE NICE FIRM KNOCKERS.

YOU'RE FIRED

Chapter Four

The view from our new inner office looked across the director's car park, where the sleek green and silver Jag saloons were parked and across into the mews cottages of Eastbourne Terrace where some months before George had parked himself on Linda. And on our new office door was a notice: "Knock Softly, But Firmly, We Like Nice Firm Knockers!"

Now we were being fired again. Or at least, someone was attempting to fire us. Standing outside our new office door was the managing director of the group, Colin. The very same senior executive who had banged the same girl as George. The one who had shown George the gun stuffed inside the waistband of his suit.

"Who put up that notice on that door?" barked Colin. He was red with rage, a particularly virulent red that contrasted extraordinarily well with his straw-coloured hair and bushy 'Wild Bill' moustache.

"I did," replied George, ignorant of the ramifications of such po-faced honesty and somewhat surprised at the managing director's overly aggressive attack. After all it was only a harmless bit of fun. Just like the labels I saw one day on one of the senior art directors desk trays, labeled 'IN', 'OUT' and 'PENDING'. As he was notoriously bad at admin, he simply re-labeled them 'IN', 'OUT' and 'SHAKE IT ALL ABOUT!'

Anyway, back to Colin…

"Take that notice off the door!"

"Why?"

"Take it off that door, now!"

"Why, it's only a bit of fun.. you see," George pointed at the carefully hand-lettered words of the sign, pointing like a teacher points to

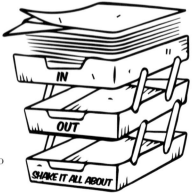

the words on a black-board, and carefully recited, "knock softly but firmly, that's polite you see…" His finger paused and then he continued running it across the last few words, "we like nice firm knockers," and added quite coolly, faking ignorance of the double en tendre, "that's also polite."

Colin was incensed; he had been away from the agency for some weeks and was now on one of his 'walk the corridors and see what's been happening tours', which some of us referred to as 'managing by walking about'. He didn't like what he had returned to either, as he had just learnt that, in his absence, one board member, the managing director of one of his divisions, had resigned, along with two other top executives, to set-up their own 'shop'. It was rumoured some of the agency's business would follow them and perhaps some more staff too. His bosses in America would ask him some serious questions about his skills, particularly relating to his keeping his finger on the pulse of agency politics and his staff-retention abilities.

Now, he was confronted by a silly junior refusing to take down a sign, which under normal circumstances would be tolerated, even smiled at, and often visited and sniggered at. After all, this was the 1970s. Bras had been burnt, and nice firm knockers were let loose, as it were, in the streets and underneath the blouses and T-shirts of London. Particularly in ad agencies. But Colin was not in a good 'Love is all you need' or 'Hey! Let it all hang out' mood.

"Take it off that door now, or I'll fire you!"

"You can't," said George, surely and firmly.

"I can, I'll have you fired!" Which of course Colin could. He was the Managing Director of the whole group. He only had one person over him, 'Dennis-the-chairman'. Directly under Colin was our boss, Mike Savino. He could tell Mike to fire us!

Love is all you need.

It was a time when love was very fashionable, anywhere, any place. And bra's were burnt, or thrown away.

"You can't," insisted George.

Colin, not wanting to get into a 'can/can't' Olympian ping-pong game simply said, "Why not?"

"Because I have resigned," said George in a matter-of-fact manner. "Actually, this week is my last week."

With that Colin tore the sign off the door and thundered off down the corridor to confront the Managing Director who had resigned. "What were his reasons for leaving? Did he want more money to stay?" And then, when that didn't work, "What the hell was he playing at, how dare he, who were the others involved, was he aware of his restraint of trade?"

In fact, during Colin's absence all three of us had resigned to Mike. Along with two senior executives, and one account executive and two PAs.

As three mere juniors, our resignations were insignificant. We didn't have a relationship with any of the agency's clients did we? How could we, as juniors?

We made our resignations even more insignificant by spreading out our individual resignations over a few weeks. First George, a month before. Then Gregory two weeks after that, and then myself, one week later.

And before, and during our resignations, we listened to the speculation about who would join the managing director and two senior staff. We added to the speculation that perhaps John, one of the senior creatives, was leaving. We poured further fuel onto the wild-fire of rumours that the other creatives were senior people who were going to be poached from another agency. A guy called Will had been seen going into the divisional Managing Director's office. In fact, Will did a lot of freelance work for him.

Within a month all three of us had left and were firmly ensconced in

our new company, along with the two senior executives, the account executive and the two PAs and David, our divisional Managing Director. The very same, who some months back said he would, 'break our bloody noses' as our rocket propelled planes whizzed and wooshed past his window with a trail of sparks and smoke.

Like I said earlier, we liked David, a lot.

FAR OUT ISN'T FAR ENOUGH

HANS PLACE

Chapter Five

We opened our small office in Hans Place, in Knightsbridge. It was a good address, just round the corner from Harrods and adjacent to Hill House School, a prep day school, whose motto is 'A child's mind is not a vessel to be filled but a fire to be kindled.' Prince Charles and Lily Allen are former pupils. The school uniform stood out amongst the suited grey of Knightsbridge — it consisted of burgundy knickerbockers, tan shirts and mustard-gold round-neck jumpers. Lt.Col Stuart Townsend founded the school in the 1950s and his wife designed the uniforms, apparently saying, 'a grey uniform produces grey minds.' (A lot of grey minds in Knightsbridge then!)

I loved watching these future Etonians, Charterhouse and King's College boys being disgorged from the rattling London taxi cabs, with a wave goodbye from mummy or nanny, or the silent arrival of a Bentley or Rolls Royce, and the grey-suited chauffeurs stepping smartly to the back door, gently drawing the door open as a future lord, or lady, all of four to thirteen years old, slid off the soft leather back seat, feet searching for the tarred road below and then, when finally finding their footing, trotting off through the large front door into the wood-paneled school.

We sub-let our offices from Dr David Owen, then Labour MP for Davenport and Plymouth. We rarely saw him. However, from the small insights I got of Labour politicians in those days I vowed I would never vote for Labour. And then, when he, as one of the original 'Gang of Four', resigned from the Labour Party and moved on to form the new Social Democratic Party (SDP) some years later, I vowed I would never vote for them either. Dr David Owen became known as a 'serial resigner' when he left the SDP as they were about to merge with the Liberal party.

However, I was delighted to hear that his involvement with politicians, and his ability to observe them 'Close-Up and Personal', led to him becoming increasingly convinced that many were mentally ill! They

Hill House School Knightsbridge. Future lords, ladies and aristocrats got a good leg-up by attending this remarkable school, including, Prince Charles and Lilly Allen.

displayed unshakeable self-confidence, contempt for advice and absolute inattention to detail. They were intoxicated with power and would lose their grip on all reality. There was no name for the condition. A condition he has, I understand, studied for over six years. So, as a medical doctor he invented a syndrome: 'Hubris Syndrome' (HS). And published a book about the subject.

He argues that Tony Blair and George Bush both suffered from the syndrome.

Good on you Dr Owen. I'd vote for you now! He is now, clearly, a man who has moved way above politics.

Below us was 'Super Travel', a niche travel company, entirely inhabited by plump Sloane Rangers and local Hooray Henry's, who sold travel packages for skiing in the winter and to North Africa and Greece during the summer. (Before Greece was discovered by the inebriated masses).

We had four or five offices on the third floor, I can't recall exactly how many, and there was one pokey kitchen with an en-suite toilet (inside and to the left of the kitchen) shared by all. Male and female alike.

The toilet had the traditional gap at the bottom, between door and floor. Had it been a public, or university toilet door, some 'wit' would have penciled, right at the bottom, a sign, probably lettered very neatly, 'Beware, limbo dancers!'

To date, the small staff in the company had got on very well. We were small and, apart from sharing the same toilet, shared the same business philosophies. We believed in thinking a lot and thinking differently. We worked hard, and slept fast. We worked together. We respected each other's professional skills. We specialised in new product development and had contracts working on such brands as Hovis, Cadbury, Benson & Hedges Cigarettes, Disprin, Dettol and Mattel toys.

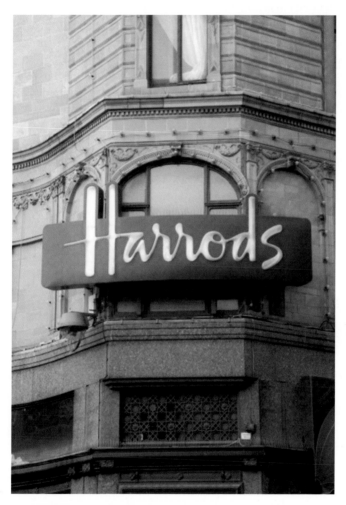

We opened offices near to this prestigious store and pratically all our shopping came from here, including the kitchen fridge.

In the early days, we didn't have to hire, but as our reputation grew we needed more talent to service the clients who wanted to come on-board. And that's when we made mistakes.

The first was an inexperienced, very enthusiastic young guy — the red-haired, rotund and bearded (closely-cropped) Michael. We hired him, I think, straight out of university. And, apart from his bright red hair and beard, he brought a new dimension to our company.

Mike certainly wasn't a student of Voltaire's who said, 'The best way to be boring is to leave nothing out!' Always willing to show his abilities, he wrote documents that were too long, as we all do at that age, until we learn that business people don't want weighty tomes (Michael actually judged his documents by weight, proudly announcing once that, "This document is one of my best because it weighs just under two pounds").

We pointed out that the actual 'Key Findings' and 'Recommendations' in the document could be condensed to a smart four pages and that the tortuous references, some forty pages or more, laboriously interwoven like some Agatha Christie detective novel, (plot and counter plot) could be considerably culled, made entirely comprehensible and put into the 'Key Findings' and 'Recommendations' very simply. And the rest, which was actually surplus to the requirements of the Marketing Director who was destined to read the document, could be put at the back as appendices, and not in the main body of the document. That's unless he really had to! He replied that he really had to, he had done all that

Mike found it difficult to 'cull' his documents and seemed to judge the quality of them by weight!

work and he wanted the client to see he had done all that work! He had a point, I guess.

After this initial event Mike wrote other documents, whose value he also judged by their weight. We coded them 'light' (which was rare) 'welter' or 'heavyweight'. The documents were then culled down to four or five pages by Mike's boss, Don.

But Mike always showed willingness and initiative. Like the time he was going on the tube during his lunchtime to buy some theatre tickets from the theatres in and around Piccadilly.

"Who wants any tickets then? For which shows? I happen to be going into Theatre-Land, what do you want?"

We placed our orders and thanked Mike for his generosity then chatted over sandwiches we had bought from Crumbs (a particularly good sandwich shop near Knightsbridge barracks which, sadly, is no longer there).

Mike arrived back shortly after two and, whilst we were still in a meeting, dished out the tickets to those, outside the meeting, whom he could find first.

At around three we opened our door, signaling the meeting was over. There, standing in the corridor, was Joe (one of the Account Directors) staring in mesmerized disbelief at his two theatre tickets.

The tickets were more expensive than Joe had expected. Not fractionally more, but considerably more. He took one ticket in one hand, looked at the price, took the other ticket in the other hand, looked at the price, put the two together, nodded to reaffirm what the total price was and then, shaking his head, and with a stifled, "I don't believe it!" strolled off down the corridor to Mike's office.

Originally "Crumbs" sandwich shop, which constructed sandwiches stuffed with the welcome delights of smoked salmon and cream cheese and duck pate.

Coming up the corridor, from the other direction, he met another member of staff, wearing the same dazed look and also doing the, 'in this hand this ticket is five pounds, in my other hand this ticket is also five pounds. Put them together and that makes ten pounds. How come Mike charged me ten pounds, fifty pence?'

"Ten pounds fifty?" echoed Joe.

"Where did the fifty pence come from?" said the other member of staff.

"I dunno, the tube fare could have only been around thirty pence return and if it was divided amongst those of us who wanted tickets, five of us, including Mike, it would be six pence each..."

At that point Mike's door opened and out he popped.

"I didn't charge you for a tube fare." Mike underlined the 'didn't' quite firmly.

Mike avoided paying the tube fare. Instead he did the unexpected.

"No, I didn't think you would do that," replied Joe.

"No." confirmed Mike. "I charged you for the taxi fares there and back, and the taxi fares in-between the theatres!"

Mike took a taxi to the first theatre. Then hailed another and another for the other theatres only a few 100 metres apart (incurring a new hire fee, each time) and then split the total fare between all of us. And then got his trip for free!

Mike continued to write the heavyweight documents, but no one ever let him get theatre tickets for them again. Then, when asked about the theatre ticket incident he pointed out to us, quite triumphantly, that, "On Sundays I often invite people for tea and cakes and then I charge them too," adding, when he saw our perplexed faces, "I've got to cover my expenses, haven't I?"

At some point Mike left. He's probably a millionaire now. Come to think of it, he probably became a millionaire by the time he was twenty-six!

Ed was very different to Michael. The only thing they had in common was the fact that when Michael left, Ed was given Mike's ex-office. Maybe the office had a curse?

Ed was in his mid-thirties, a chap. He usually wore the loudest of striped shirts (they closely resembled pajamas) and those heavy Hank Marvin spectacles. His portly frame was often loosely covered in a slightly over-sized pin-striped suit. He sweated a lot, he drank a lot. His hair was long, straggly, black and unkempt and he never washed it himself, preferring to have it washed, by another's hand, twice a week at Sassoon's in Sloane Street.

Ed's big specs enjoyed eye-balling the odd adult mag.

He called everyone 'luvvy.'

When I asked one of the directors why we had hired him I was told, "Ed is a very clever man." Clever he was too, to hoodwink his way into our company!

Ed had his meetings in the mornings. In the afternoon he usually had a little rest. A rest after the wine, port and cheese he had consumed at Bill Bentley's wine bar in Beauchamp Place.

His rest consisted of putting his feet up on his desk, leaning back into

his chair and gazing and chuckling at the pictures in the magazine he would be pondering upon. The magazine was usually Penthouse. Or at least one of that ilk.

His pondering would take some time. How long I can't remember, but I do remember we made it a rule not to meet with Ed in the afternoon, unless we had to.

The director responsible for hiring Ed eventually realised he had got a dud but, although regretting his mistake, he found it hard to accept. Marjorie, the Head of Research, couldn't help noticing, almost every afternoon, the feet perched indifferently on the desk, the open copies of Penthouse being blatantly eyeballed and the pages slowly turned, accompanied by a gentle grunt of appreciation, or occasionally a little yelp of surprise. It all began to add up. Ed needed to go.

It was done very quietly. Nobody noticed, or commented. Except one person, Marjorie. She was an 'Oxbridge' graduate and a 'proper lady.' If you didn't know her better you would say she was a 'Sloane Ranger.' She never swore, ever. Neither did you swear in front of her. She was a stout Roman Catholic. She was elegantly mannered and certainly would never peek inside a copy of Penthouse.

Each afternoon, when Ed was in his office, we waited for Marjorie to go to the kitchen, which, as luck and convenience would have it, happened to be opposite our office door. We waited several times and then finally, after many false alarms, she went into the kitchen and then into the loo. The door was bolted, the 'Engaged' sign displayed. Trapped for a few precious moments at last.

We took a quick look down the short corridor to Ed's office. He was glued, pop-eyed, to the usual magazine. One of us stood by to warn the others if Ed made a move.

We then took a copy of Penthouse we had previously borrowed from Ed's stash, opened it at the usual cliché centre double-page spread. It was some voluptuous naked blond (save for the usual red g-string) spread across the two pages, her breasts looked like slightly under-inflated party balloons (big and, firm, but a touch wobbly), her lips glossed over and in a seductive pout, one of her hands tweaked one nipple, the other hand playfully twanged her g-string. We tiptoed into the kitchen, bent down, and slid the open-copy under the convenient gap between the loo door and the floor.

We made sure the magazine remained in our grip, although it would have been hard for anyone sitting on the seat to bend down and make a grab for the magazine, without toppling off the seat of course.

After a few tantalising seconds, just long enough to shock the seated Marjorie, we retrieved the magazine. Nothing was said inside the loo by Marjorie, or outside, by us.

We returned to our office and got on with our work. We heard the 'clunk' of the chain and then the 'whoosh' of water as the toilet flushed. Then the 'click' as the door bolt was slid back to read 'Vacant'. There were a few measured stiletto steps on the linoleum which led to the basin, where she washed her hands and dried them on the fluffy hand-towel. Then we heard the sound of her muffled and hurried footsteps, on carpeted floorboards, disappearing down the corridor, we presumed to her office, which went past Ed's where, as we had happily confirmed earlier, he sat in his normal nonchalant afternoon pose absorbing the pages of flesh. He may have even looked-up over his Hank Marvin spectacles and given Marjorie a cursory glance as she passed his open door. We hoped that he would.

The 'Sliding of the Magazine' exercise was repeated when conditions were right. That was always when Ed was back from a good lunch. Always when he was thoroughly ensconced in his office without any meetings. Always when Marjorie was firmly locked in the loo.

I think three or four times was enough.

Eventually Ed left. I wonder why?

He was never one of us, anyway.

All's fair in love and "advertising".

SALLY AND THE POLICEMAN'S HELMET

Chapter Six

"Does anybody want a ciggy?" enquired the breathless blond, as she poked her head around our office door, making George swing round swiftly in his chair and turn from his layout pad. He looked up at her adoringly.

Sally was George's latest conquest. And in a couple of months' time would be his most embarrassing conquest of all.

She was a little different from the rest. The archetypal breathless blond. She fluttered her eyelids at all of us and, as she pushed the office door open, the gentle movement made her breasts, unencumbered by a bra, wobble and then ripple her white silk blouse. As her nipples stroked the inside of her blouse, they reminded me of two boisterous puppies whose playful noses might prod the underside of a silk sheet as they played below.

I looked across at George. He had that familiar, small, almost smirky smile, the smile of the cat that got the cream. Not just the top of the cream, but all of it.

She was too gushing for me. And too gushing for Gregory too. And to be honest, we were perhaps a little jealous too. But as George was the 'looker,' he always got the girls.

However, we both wondered what George's mother would think. Living at home until recently, George was still tied to home by his mother's elastic apron strings, strings that would invariably pull him home each weekend. For a few square meals and the inevitable bag of washing that needed to be done.

George's mother was German. Indeed, she looked like she could have come out of one of those German archive films where you see row upon row of glamorous fraulines dressed in regulation white shirt, black shorts and black plimsoles, all with bunched-up blond hair, doing star jumps and knee bends for the benefit of keeping the Aryan race fully fit.

George got pulled home each weekend by his mother.

As a German she was, of course, very strict. She loved her George and made a real fuss when he was at home and always enquired about his life away from home, and that enquiry included an in-depth report on his girlfriends. Indeed, she wanted to meet them all, to vet them of course! Well, somehow Sally was not revealed to George's mother. Not just then.

So that's the introduction to Sally then. Racy, braless, and did I forget to add, flirty, adventurous and just a little wobbly in the bottom department too?

Dave was a photographer we used for a lot of our advertising work and he had become a good friend. We spent long hours in his studio in Grafton Way, off Tottenham Court Road. Mike was Dave's partner at the studio, also a photographer, and now more or less living off the income that Dave provided from his Benson & Hedges shoots along with Mike's share of income from 'Baseboard', a black and white photographic printers famous in their day for processing a lot of the Twiggy shots.,.

"Yeah," Dave whispered, "Yeah, she's been here with Mike and Mike's been giving her the old one:two, know what I mean?"

Actually, I wasn't quite sure what Dave meant. Mike gave a lot of girls the 'old one:two' as he was recently divorced (in fact that's probably why he got divorced as I suspect he was giving many a girl 'the old one:two' whilst he was married too). However, I wasn't quite sure this was the sort of 'one two' that Dave was referring to.

"Yeah," he continued conspiratorially, "George introduced her to Mike and Mike's been, you know, photographing her."

The puzzle began to fall into place. George introduced someone to Mike and Mike has been photographing her. But who was 'her'?

Dave read my thoughts, "Sally mate. Sally! You know George's bit of stuff."

As Sally was a little bit of 'looker', one could expect that to happen. Like every girl of the 1970s and part of 'Swinging London', she would have loved to be a famous model. But what I didn't expect to hear was what Dave said next, and what he then said, as an addendum to that.

"Sally you know…" he lowered his voice to a whisper, "Sally was the… was the, you know, the Kingston Bridge Streaker! She was the girl who stripped off to her birthday suit and streaked across the Kingston Bridge and then got nipped on her arse by a police Alsatian."

"The one that was in all the newspapers, the front page of all the tabloids? The one that was on the news?"

"Yeah," chuckled Dave, "Didn't you see the pictures of her in the papers?"

"Yes Dave, I did, but it didn't dawn on me that it was Sally, after all it was a photograph taken from the rear, on a telephoto lens, wasn't it, and well, I'm not used to seeing Sally, either through a telephoto lens or, more to the point, naked from the rear, am I?"

"I bet George has seen her naked from the rear though, know what I mean?" quickly quipped Dave.

"After all," I continued, "All wobbly bottoms are the same, aren't they?"

"S'pose so." said Dave, as he pulled out a copy of the paper.

"There," he said as he pointed to a black and white picture of a girl, stark naked, with a policeman and police dog escorting the curvaceous blond from the bridge, the policeman's helmet strategically positioned to try and cover the girls' buttocks, though it only covered a part of her right hand 'cheek'. The headline in the newspaper read something like,

'You're Nipped!' It was big news; yes Sally was the first female streaker in Britain to be nipped by a Copper's dog. She was famous. And soon to be more famous too…

"And," added Dave in an excited addendum, "she's been in the studio with Mike who's been photographing her in the 'nuddy', you know — fucking naked!" He could hardly contain himself, "for six pages in a Mayfair-type magazine!"

He put the newspaper down to make room for his gesticulations. He mimed the pulling down of panties, "You know, showing her fanny," then he spun around sticking out his backside. "He's photographed her arse too, the side that got bit," and then Dave moved his cupped hands up to his chest and, in mock movement, bounced them up and down, "her titties too, the lot! Woweee! Three double pages in Mayfair. All is revealed. All is on display!"

"So when's it coming out then?"

"I don't know, maybe in a couple of weeks," replied Dave. "Don't tell George that I told you. Mum's the word."

So, I relayed the information to a startled Gregory who roared with laughter. What would George's mother say if she knew? What would his father say, the epitome of an English gent, if he ever knew.

Of course, it was doubtful that George had ever introduced Sally to his parents, so even if they had seen the pictures in the paper they wouldn't know it was the girl that their son had been taking out. He was safe from retribution and embarrassment there. At least.

But he wasn't safe everywhere.

Gregory and I hatched a plan.

In this case a policemans job was ♪ a very happy one. Happy one. ♪

Every month we went to the newsagent, and when we thought no one was looking, we peered into a fresh stack of Mayfairs. For two months we did the same, the newsagent must have thought we were a couple of poor 'pervs,' surreptitiously walking into the store, strolling over to the 'dirty mags' section and hurriedly picking up a copy of Mayfair. Opening it at the centre spread (where Dave had told us the piece would be) and then, disappointed, we would shrug our shoulders and, closing it, stroll out, without buying a copy.

We were beginning to think it was all a hoax. Perhaps Sally had got cold feet and called the whole thing off?

The third month arrive. And bingo! There she was! Sally peered at us (or rather her fanny did, and her buttocks, breasts and pursed lips – which were coyly licking her index finger) from the centre page of Mayfair. There she was, three double pages of Sally in the usual sexy and clichéd positions. There she was along with a reprise shot of the news photo that brought her fame through the papers, of her, the policeman, the police dog and policeman's helmet. It was accompanied by a short excuse for editorial. It asked and answered what she did, where she worked, how old she was, why she did it and so forth. I can't remember what those answers were but I certainly remember her ambition was 'to be a model'.

Having not bought anything from my previous sorties into the newsagent's, I think he must have been gob-smacked when I bought six copies and hurried out to our office round the corner. It was around 8am, an hour before we normally arrived.

Gregory greeted me with a couple of copies under his arm. We quickly got to work. It took about 40 minutes to get the office ready. Satisfied with the effect we then sat back and waited for George.

He strolled in around his usual time: 9.15am.

"Morning guys," said George.

"Morning George," we replied in unison.

"Good weekend?"

"Yep, fine," I said.

"Yep, great," said Gregory.

"Coffee guys?"

"Yes please, George." He left the room to get the fresh filter coffee from the pot down the hall.

"He didn't notice a thing!" exclaimed Gregory.

"Nope, wait, you'll see."

A few minutes passed, which gave Gregory and me a chance to compose ourselves and calm the nerves, which were driving slight smiles across our about-to-be aching faces. George returned with three mugs of coffee, which he divvied out, plonking them down on our desks. First Gregory's desk, then mine. Gregory's and my desk faced George's. George walked towards his desk, Gregory took a glance at me and George and sat down in his chair. He reached into his pocket and looking down he tapped out a Stuyvesant from the pack. As he did so, I took a quick glance at Gregory. Gregory smiled nervously back at me and immediately bowed his head and looked down at his desk, avoiding further eye contact with me should it ignite a tell-tale smile or nervous snigger.

George took a sip from his coffee mug, enjoying the fresh nutty taste and caffeine punch that only good, fresh-ground coffee can deliver. He put the mug down on his desk, stretched his arms out by his sides, brought them together again and with his left hand popped the unlit Stuyvesant between his lips. His right hand reached into his jeans side pocket and

retrieved his Zippo lighter. I looked up, then down again.

I heard the clink of the Zippo opening and then the spin of the flint, followed by that soft 'woof' as the cotton wick took to flame. I looked up momentarily and saw George looking at the Zippo's flame (have you ever noticed the pleasure Zippo lighter owners take in the quality and length of their flame? A bit like the way people take pleasure in the sound of their motorbike when they rev it. Or in the sound of their sports car's tuned exhaust. In fact, I do believe Zippo lighter owners actually spend time honing their lighter's performance. Length of spark + ignition time + length of flame = satisfaction).

Anyway, here was George staring at the flame and Gregory and me taking furtive glances upwards, then immediately downwards, to guard, and delay, our soon-to-be-released hysterics. George moved the flame to the Stuyvesant; he inhaled, removed the cigarette from his lips and with a quick stab of breath blew out the Zippo's long, lazy flame. He popped the cigarette back between his lips; inhaled again, deeper than the first, clicked the Zippo closed then slid it into his jean's pocket. He let the cigarette sit between his lips for a second or two then he took his right hand to the cigarette, took a longer satisfying drag, removed the cigarette from his lips and then exhaled sending out a long stream of smoke punctuated by a couple of expertly blown smoke rings which rose to the ceiling. He watched the rings rise, he arched his back, leaned backwards in his chair, stretched his arms to his sides again, and froze.

He was agog.

There, facing George, stuck to the top

The Zippo lighter lit George's cigarette
and we waited for him to ignite with rage.

of the Georgian office wall, was a massive display of Sally. She was taped to the cornice that ran round our twelve-foot high wall. Eight copies of Sally, save for a G-string guarding nothing, naked in Mayfair.

At first George didn't say a word. He just stared. Then his head turned gently from left to right. He took the scene in. Eight times six double pages of Sally. Forty-eight pages in all.

His eyes followed the line of the cornice. They paused at the end of the paper display, and then returned to the middle. He put his hands behind his head and, still looking up, breathed out heavily.

I'm sure, as his eyes ran across that brazen display, his thoughts were going wild. 'You fuckers. Oh dear, what have I done? What will mother say when she finds out? But she doesn't know I took Sally out, I didn't tell her, or did I? My sister knows I did, and her friends know, surely they don't read Mayfair? After all they are all teachers and teachers don't read Mayfair. But maybe they do, the ones they confiscate from the school children. The ones they find the boys reading behind the bicycle shed. But that man next door, he worries me, the one in the long flapping raincoat, he looks like he reads Mayfair. Oh shit, what will my mother say, she who has succoured me, fed me, and washed and ironed my seven pairs of Y-fronts for years. My father will disown me. And my clients? I shall not be able to look a client in the face. They will say, 'don't even try and defend the work you are presenting to us today, George. Tell us George, how naughty was Sally? Really naughty? She was wasn't she? Go on tell us, we won't tell a soul'. And then what will they say when the staff and directors walk into this room and stare up at those pictures. They are going to walk in any moment for an early morning chat. What will they say at Bill Bentley's Wine Bar in Beauchamp Place when we go there for a Friday night drink? 'Oh look chaps here comes George the Poker of Sally the Streaker.' Oh shit, oh fuck!' Instead all that George could say was, "Bastards!"

That was followed by, "Take them down!"

"Can't," said Gregory triumphantly, "we haven't got a ladder."

Impulsively George grabbed the phone on the desk and punched in a three-digit number. As George waited for his call to be answered Gregory and I swapped hurried glances. Smiles broke out but lips remained taught, teeth were clenched.

"Stan?" said George. "Good Stan, a spot of bother here, can you bring up that long ladder?"

Stan was in charge of general office maintenance. He had a toolbox full of pliers, screwdrivers, wire-cutters, spanners, drills, hammers, electrical plugs and sockets and a selection of screws and nails. And a ladder. A ladder that extended to a good ten feet. One that was ideal for replacing the bulbs in the shaded wall lamps that adorned the white office walls, one that was ideal for the cleaners when they wanted to reach the dust that had settled in the ornate cornices that bonded wall and Georgian ceiling together.

It was ideal. But it wasn't available today.

"What?" said George. "Not available? What do you mean?"

Gregory and I guessed what Stan was saying – he was saying he couldn't find it, and didn't know where it was. He was looking for it himself only this morning to give the windows the 'once over' before the office opened. Strange, that it had disappeared, this of all mornings, is what Stan was saying.

We knew what Stan was saying because we had told him to say it when we had borrowed the ladder from him first thing, to put Sally up.

"Shit," said George, as he slammed the phone down.

Gregory looked back at George and shrugged his shoulders. His mannerism said everything. It said, "Huh, so what can we do now George?"

"Come on guys, that's enough now," implored George.

When you catch a fish you 'play him' out. That's, in a way I guess, what we were doing with George. And we were savouring the moment. As you do when, at last, you have that fish on the line. You've taken time to catch him, you've chosen the place, found the bait and set the hook. Now we were savouring the moment. Reeling him in. Steering him

We played George like he was a fish on the line.

away from the reeds, stopping him from getting off, stopping him from wrapping the line round a rock, pulling him in a direction we wanted him to go. Yep, that's what we were doing with George.

Now we had dragged him onto the beach, gasping, and in a flap.

"Come on guys, please, what if some of the others walk in?" said George.

I reckon George's biggest concern about the 'others' was if the devout, never-swearing, Head of Research, Marjorie walked in. Here was a bunting-like display of pages from Mayfair, twenty-four feet of Sally emblazoned on the wall. And although Marjorie would not recognise Sally's body parts, she certainly would recognise the head, as she, like all of us, had had 'drinkies' with Sally in the various pubs and wine bars that were found in the nooks and crannies of Knightsbridge.

"Is Marjorie in today?" I said innocently.

"Take them down!" insisted George.

Finally, Stan miraculously found the ladder and we did remove the pictures. Marjorie never got to see them and George never got to see Sally again. Not in the flesh anyhow. It turned out that when he realised that Sally was really going to appear in Mayfair, he ended the relationship.

History doesn't relate, however, whether George's mother and father ever got to see the pictures.

BILL BENTLEY'S

Chapter Seven

"I bet you can't climb up that tree."

It was Friday night and we were on the back garden patio of Bill Bentley's Wine Bar, in Beauchamp Place, Knightsbridge.

Bill Bentley's was alive at lunchtimes and evenings. It had some not bad food, and some good wines and chilled oysters, served by equally chilled staff. It's a popular place for sozzled Sloane Rangers and their merchant banker boyfriends who boast loudly about their fat bonuses and frequently fall off their bar stools. If you wanted a little entertainment on a Friday night it was a good place to be. But you had to get there early. It filled up quickly. (Unfortunately Bentley's has now disappeared from Beauchamp Place and a classy, brassy and equally expensive Japanese restaurant and sake bar, called 'Chisou' has taken its place. The 'Cynthias' ,'Antheas' , 'Nigels' and 'Simons' still go there, over-imbibing on the imported Japanese firewater. Many eventually slide off their chairs onto the floor or, more often than not, gently head-butt their expensive plates of sushi).

We had got there early and shared a bottle or two of Chablis. Gregory, George and me. And Don, one of our directors, and Andrew, a Millfield educated Account Director who had finished his graduate trainee scheme in Madison Avenue.

Because we had got there early, we had managed to snuffle a prime table on the vine-covered patio. We sat at one of those ornate white wrought iron tables with matching chairs, the ones that put an imprint of their pattern on your bum. The patio was a bit of a suntrap and the only shade was the vine and the large tree (a Sycamore, as I recall, with a six foot girth) that overhung the patio and grew in the back garden of the large early Victorian Terraced home that backed onto Bentley's from number Thirty Four, Walton Street.

"I bet you can't climb up that tree." It was Don who laid down the

Bill Bentley's. Now a posh Japanese resturant, at the time of writing this book.

challenge to Andrew.

Andrew was, and still is, very competitive. Particularly where money is concerned. In fact, Andrew was the guy who was put in charge of moving our offices and negotiating a lower price from the removal company. Andrew was the guy who, three times as I recall, was put in charge of arranging the Christmas lunch for our small company of twenty-five people. A Christmas lunch in France each year, and each year he beat the price of the previous year's party, downwards, not upwards!

One year he saved the company lolly by booking us all on a 'Christmas Shopping Special' – an all-inclusive trip by Hovercraft to Calais, where the ticket included a brief trip to the local supermarket to buy French wines, pâtés and so forth. Andrew managed to negotiate that we bypass the bus trip to the supermarket and instead arranged for us to be picked-up by a coach and taken to a fine French restaurant for shrimps, pâté, beef Wellingtons, fresh fruit salad, a gargantuan gateau and cheeses. Washed down with copious amounts of Chablis, Nuits Saint George and port. As the Hovercraft landed, the BBC, who was making a feature of money saving ideas for Christmas shopping, were there to greet the passengers and ask them what they were going to buy on their 'Special Discounted' shopping trip to the supermarket. Cheese? Wine? Beers? Belgian Chocolate? When we gathered around the microphone and camera they were gob-smacked to hear we had, 'Just come over for lunch!'

But here we were now, in Bill Bentley's. It was a Friday night, we'd just popped in for 'drinkies' and the challenge had been laid down. Would Andrew climb that tree?

Andrew contemplated for a moment.

"For money?" he asked.

"Five Pounds?" said one of us.

Walton street, Knightsbridge, where Andrew took the butler into his confidence.

There was now a long considered pause from Andrew. Had he bitten off more than he could chew? The tree grew over the patio, but the trunk was securely guarded inside the garden that overlooked the patio.

He looked up, there was no overhanging branch he could reach, even if he stood on the ornate table and reached up. And Andrew was tall, about six feet six, as I recall. And agile and wiry.

Could he somehow jump? No.

Was he allowed a 'bunk-up' from one of us?

"No."

Any physical assistance?

"No."

He looked at the trunk; it was behind the black palisade fence that ran the width of the rear garden of the house in Walton Street and Bill Bentley's patio. There were no convenient horizontal straps that he could use as a toehold. Neither could he enter the garden from the street side. There was a seven foot high brick wall, without any foot holds, running the length of the street, parallel with the garden, which connected the house, to the left, to Bill Bentley' wall on the right (viewed with your back to San Lorenzo's – the restaurant with truly appalling food, which for some reason attracted the hoi polloi, with, obviously, equally appalling taste. If you want to see how money can't make you

happy, or money can't buy good food, eat here).

Stymied, Andrew took a sip of wine. He surveyed the tree, the trunk and then the palisade. Then a broad smile broke out across his face.

He excused himself, probably to go the gents, and then returned some five minutes, or so, later.

"Ten Pounds?" Andrew asked. "And a bottle of champagne?"

"Moët & Chandon?" enquired Don.

"Dom Pérignon!" insisted Andrew, knowing the true value of everything.

"OK", we agreed. And stated that if he didn't complete the task he would pay us the ten pounds and give us the champagne.

He smiled the smile that I have only ever seen Andrew smile. The broadest and cheekiest of smiles. It is as wide as he is tall; it spreads from the middle of his already wider than usual lips, and spreads to the extremities of his cheeks.

"OK, you're on."

"No ladder?"

"No."

"No bunk-up?"

"No."

I have to add here that Andrew was one of the first stars of a new TV show, produced by Granada and aired on ITV on, as I remember, a Wednesday night. The show was The Krypton Factor. It had a huge following, and first ran from 1977 to 1995. The contestants were very different to any others of that time as they competed against each other

in a series of rounds that not only tested their mental ability but their physical ability and stamina too.

The mental ability often took the form of a memory test (though other versions would require mental computation of time and date differences, or to add up a sequence of numbers and return the number which, when added to that sum, gave a pre-determined answer). The contestants frequently had to memorise a sequence and then answer a series of progressively more complicated questions. For instance, if the sequence to be memorised was a series of coloured blocks, the questions might start as, 'What is the colour of the third block from the left?' and progress to, 'What is the colour of the block two to the left of the block to the right of the green block?' Try it at home. Difficult isn't it? Other forms of memory test might require contestants to remember a phrase or proverb and answer a series of questions about it, like, 'What was the third letter of the tenth word?'

Mental agility also featured two or three-dimensional puzzles where shapes had to be put together to fill a rectangular grid, or make an even bigger shape.

Probably the most memorable of the rounds was a pre-recorded segment which involved the contestants racing to complete an army assault course at Holcombe Moor in Bury, Greater Manchester. This round typically included 20 obstacles including climbing vertical and flat cargo nets, swinging on ropes to cross muddy water jumps, and crossing trembling Burma rope bridges. It usually finished with the contestants slithering down a rope slide and splashing into dirty water.

Andrew was great at both mental and physical agility (and made it through the early rounds, into, I think, the final). And now he was about to demonstrate these abilities to us, and the attendant lushes, in the back of Bill Bentley's Wine Bar that Friday night.

Andrew had left the table for some twenty minutes; during his early absence there was much discussion about where he had gone, 'To fetch a ladder?' or 'To change his clothes?' or the most frequent of all the remarks, 'He's given-up and gone home.'

Another bottle of wine was drunk and the bet became a faint blur on the distant horizon of the past busy week.

Suddenly there was a crash and a crack above us and a sprinkling of twigs, leaves and assorted debris clattered down onto our table, onto our heads and into our drinks.

"Far enough?"

We looked across and into the tree. We couldn't see a thing. Mostly because our eyes were still smarting from the twigs and dust that had got into them, but also because we weren't looking far enough up the tree.

As the dust settled, we adjusted our angle of sight, to an elevation of around forty-five degrees - a view of some fifty feet up the tree.

"I said, far enough?" cried the voice.

My vision cleared and "There!" said someone pointing up the tree.

"Where?"

"There, just where the main trunk splits into two, there he is, next to that big bird's nest!"

I squinted and there was Andrew, halfway up the tree, hugging it like a wide-eyed, long-legged lemur lovingly embraces a teak tree in Madagascar.

"Oh gosh," said a deb.

Andrew, a lemur?

"Jolly bwave," said a half–cut merchant banker.

"Fucking hell," I thought.

I remember thinking how bizarre Andrew looked. He wasn't even dressed for the occasion. He was wearing those Gucci slip-on shoes (you know, the ones with the gold horse brass and the green and red Gucci tags), a pink and pale blue shirt (the kind that often get mistaken for pajamas) and pin-striped trousers. The only things he had discarded were his suit jacket and his knitted pink tie.

And he was wearing the broadest of grins.

"Far enough?" He challenged us.

"Not quite," we said in unison.

"Where to now then?"

"Another twenty feet should do it," said Don.

"To the top," said others.

"Twenty feet, should do it," repeated Don, adding that he didn't want Andrew to come crashing down impaling himself on the fence or landing on the attendant crowd of colleagues, debutantes, Sloane Rangers and merchant bankers below.

So off Andrew went again, carefully selecting hand and foot holds. Again, he reminded me of a lemur, slowly appraising the surety of each hand and foot hold before he would carefully reach out to make another slow and deliberate pull of a hand, or push of a foot, to gently thrust himself up the tree.

Occasionally more debris would spin down and hit our drinks with a 'ping,' or land on one of the merchant banker's heads eliciting an, "I say

old chap, watch out up there, there's champers down here!"

"Enough!" said Don. "That'll do." And we agreed it would. Andrew had climbed all but the last thirty feet of a very tall tree. How he had gotten there we didn't know. Before announcing his enigmatic arrival at the split in the tree, with a shower of twigs and dust, he had climbed silently and un-noticed up the tree. How did he get to the bottom of the trunk in the first place? It was guarded with black palisade fencing from the Bill Bentley's side. And the garden of the house, with the tallest of walls, was inaccessible from the Beauchamp Place side. Was it his Millfield boy's military training that somehow allowed him to shrink and get between the bars without us noticing? After all, he was the epitome of a beanpole, the thinnest of all of us. Had he climbed out of the gents' window at Bill Bentley's and managed to grab a bough?

We returned to our drinks and waited for Andrew's triumphant arrival.

"Hello," he said cheerfully, as he bounced up the steps onto the patio. He dusted himself off and drew up his chair to the table.

He took a sip of his wine, leaned a lanky arm on the table and smiled.

"So?" one of us said.

"So, what?"

"So how did you do it?"

"Hah!" grinned Andrew.

"Hah, what?"

"Well…"

Andrew, not one to gamble, then explained why he had left the table before he had accepted the bet.

And why he had raised the bet, from five to ten pounds.

When he had initially left the table he had strolled round the corner to the house in Walton Street, given a 'rat ta ta tat' on the brass door knocker and, unfazed when a butler opened the door, enquired whether the butler would kindly let him enter the house and walk through it to the back garden?

The startled butler asked why, and Andrew explained that his colleagues had challenged him to climb the tree that was in the butler's employer's garden.

"The one that overhangs Bill Bentley's?" enquired the butler.

"Exactly!" responded Andrew. He would be very much obliged if he would be permitted to do so.

"How much obliged would that be?" asked the butler. Andrew replied it was worth five pounds of obligation!

"It was that simple," said Andrew. "So give me the ten pounds, two fivers would be best, so I can pay my debt to the butler."

The 'dare' was worth five pounds of obligation,
to the helpful butler.

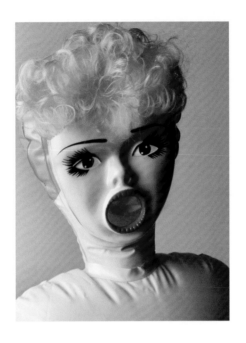

TARTS & THE BROWN ENVELOPE

Chapter Eight

This was my moment of despair.

By now I was working in the agency's Brussels office, not only for the fabulous food and a variety of very esoteric beers, but also because it gave me the opportunity to work with some great international clients and handle some brands right across Europe in several languages. A challenge I couldn't resist.

"And this," said Jacques, the Account Director, as he handed me the big fat brown envelope, "is for Monsieur Pierre."

I was about to embark on a trip to photograph the sun-drenched beaches and bodies of Nice, in the South of France. Girls in bikinis that made the width of a postman's string look positively large in comparison. Wiggles and wobbles in all the right places, with their bikinis working overtime to keep everything 'up' and 'in'. Utopia. With six gorgeous models and ten days to photograph them for a new advertising campaign.

Yes, it should have been Utopia, but then there was the brown envelope, full of Euro-Cheques, that Jacques was proffering.

And there was the client, Monsieur Pierre, chairman of a very large French consumer goods company. He detested me and I can't say I liked him much either. Some months back he asked, no, actually demanded that I never work on his business again as I had stuck to my guns over a campaign the agency had presented to him. He turned it down. I stuck to my guns again, in retrospect, far too zealously and well, he asked for me to be removed from working on his account.

I was glad to see the back of him. When most people of his age had one chin, he had three. They all flapped as he spoke. They flapped too, as he ate and drank, copious amounts, always insisting on Le Menu Gastronomique. And of course the wine, his eyes and podgy index finger always settling on the most expensive wines (one for every

course) and the agency invariably paid. He always held court at these dinners and lunches, and his underlings cowed and quivered whenever he spoke. Indeed, he was the perfect template for the bombastic, bossy and bullying client. (As my mother would say, on a good day, 'Not a nice man at all.', and on a bad day, 'A bit of a bugger, dear'.)

"Pierre has specifically asked for you to go," said Jacques. "I think he respects you for standing-up to him."

Respects me? I think not. He turned down all the photographers we recommended, finally introducing us to a photographer from London that he felt was, 'just the right man for the job'.

Just right for the job? What? This was to be a photographic shoot on land, on the beaches and in the fashionable cafés of France. On land, yet, wait for it folks, this was a photographer who specialised in underwater photography!

Hey, this doesn't compute? Well not yet, anyway.

I had heard stories of the 'Brown Envelopes' before, urban legends in the world of advertising, but never seen one. Now here it was, being proffered to me in Jacques' outstretched hand.

"Take it," he commanded, "I won't be coming with you, and you are on your own."

I was being punished. Perhaps.

On my own? With two clients, Pierre, the Chairman, and Claude, his lap-dog marketing manager pulling at the leash, hungry to be in the South of France with six gorgeous models and ready to lick the Chairman's boots at any and every opportunity.

Claude's mind was racing with fantasy. The best hotel in Cannes,

great food, fine wines, cognac, cigars, lobster and 'Totty.' Was it true what they said about these models, he thought? After all, he and the Chairman were the client. The bosses. The men with the big sticks. The godfathers. They were in charge! They paid the bill. And he who pays the fiddler gets to call the tune, right? So it was, er, sex perhaps? 'Bien alors!'

Then there was the photographer, the plumpish Brian, an unfit Essex lad, rounded face, devoid of any real distinguishing character, with heavy black spectacles on his pug-like nose, and his assistant, Geoff, thin like a wiry rake. He carried all the bags and equipment, while Brian usually sat or leaned against the nearest wall, or pole, smoking the same brand of cigarette as the client. He was the prime example of a well-cultivated couch potato and did little more than lift a cigarette to his mouth or a camera to his eye. He sweated a lot, causing his spectacles to slide down his nose, so he was endlessly prodding them upwards towards the bridge of his nose with his pudgy forefinger, particularly when he was nervous.

Counting me that made um, eleven. And no Account Director.

Almost, without fail the Account Director accompanies the client on shoots, to keep them happy and content. No Account Director meant one thing. I had the total responsibility of directing the photographic shoot every day and looking after the client's entertainment, whatever that might entail.

And, of course, I had the responsibility of the fat 'Brown Envelope'.

"It's Pierre's expenses," said Jacques. He said it slowly and deliberately and when he said 'expenses' he sort of squeezed it out, with a smirk, mixed with a touch of distain, at the same time looking away as you would when you smell something disgusting, like a dog's turd. Or a bribe.

"Give it to him when you arrive. He's expecting it," Jacques said, as he turned his back and waved goodbye. "Oh, and good luck!"

I think Jacques was happy to be staying behind. A bit like the guy who cast the rope from onshore as the Titanic sailed away, Jacques was happy to see us go. Perhaps it was pure intuition on his part, a sense that something odd and embarrassing was going to go down. And he wasn't wrong.

We arrived at Nice Aeroport (Côte d'Azur); Claude picked-up the white Mercedes 280SL from Avis whilst Geoff and Brian picked-up the mini-bus from Budget. Geoff loaded the camera equipment into the back of the bus, Claude loaded Pierre into the back of the white Mercedes, chauffeur style, and Claude drove, whilst Pierre sat regally in the back. He nodded in approval at the plush leather seats; very content and somewhat smug, he looked a little like one of those big fat toy noddy dogs you see on the back shelf of, usually, lower class cars, head nodding up and down, and from side to side, as the car ran over the 'sleeping policeman' speed bumps.

After exiting the airport slip road they gently glided off on the ten-minute ride to our hotel in the Promenade des Anglais. I joined Brian and Geoff in the bus.

Pierre nodded, just like a doggy in the window.

The six models had arrived earlier on an Air France flight, direct from London.

We checked into the beautiful Belle Époque-style hotel, right on the seafront, and we found Monsieur Pierre had immediately gone to the bar and was addressing the six models and nodding approvingly as he was undressing them with his eyes. He bought everyone, "Champagne, of course!" gesturing to the waiter to bring a bottle and glasses for all.

There he stood. One hand poised, champagne glass held imperiously on display, the other hand in his trouser pocket so as the corner of his jacket was pinned back by his elbow and forearm, revealing a billowing belly slumped over his trouser belt, tight with previously consumed champagne, fine wines, richly-sauced Belgian foods and chocolate. Monsieur Pierre was in full stride. A commander addressing his troops.

When there was a lull in his address and those listening to him turned to chat to each other, he leaned towards me, and from the corner of his rubbery lips he whispered, "You have the envelope…the money, of course?"

"Good," he said, without waiting for my reply.

After a genuine five-star dinner we, well, Brian-the-photographer, Geoff-the-assistant and all six models and I went off to our rooms to get a good night's sleep as we had an early start the next day. A 4.30am call.

We left Monsieur Pierre and Claude at the table, with protests of, "Stay for another drink my friends, the night is still young". The two of them were swaying gently on their chairs amidst the debris of a generous, and now heavily plundered, cheese board and a half-empty bottle of Poire Williams in front of them.

"We have an early start," nearly all of us replied in unison.

"Good night then," said Monsieur Pierre, "Ssssseee you, in the morning,

hey bwight eyed and bush, bushy tailed. Sllleep well, mes enfants!"

We slept well only to be disturbed by the unwelcome early morning rattling ring of the morning call, which had me sleepily searching for the location of the damned phone and wondering where I was all at the same confusing time. Having initially driven two legs down one trouser leg, I eventually got it right and dressed hurriedly to arrive at reception, as agreed, bang on 5am.

"Where are they?" asked Brian, sighing and biting his knuckles. It was morning, we were in the hotel lobby (we, being Brian and Geoff, all six models and I). No sign of Monsieurs Pierre or Claude.

"Where are they?" Brian uttered again.

"Let's go, we need to get to the plage; Monsieurs Pierre and Claude can follow on in their own time," I said.

With that, we all bundled into the bus and made it to the beach with the sun still down and the sand pristine. Not a person in sight, other than the girl, as thin as a pencil, walking her lanky-legged Great Dane along the promenade.

It must have been 11.30am before Monsieurs Pierre and Claude showed-up.

"Hello," panted Monsieur Pierre as he put on his cheeriest of faces and, along with Claude, kicked and stumbled his way through the softly trodden sand, now heavily marked, concave and convex, by the passers-by who had gathered to see the small group on the beach, photographing the 'belle femme' for the 'publicite.'

"Out of the way, out of the way," Pierre indicated to the crowd; they must part, make way, sort of, well, like the Red Sea parted for Moses.

Geoff unfolded two director's chairs for them. Both flopped down, relieved and weary, mostly from the night before, and no doubt from their five-star breakfast and, of course, weary from their short struggle down the recently well-trodden beach. (We had rolls and jam and delicious coffee from a flask and fresh fruit that room service had packed for us the night before).

Slumped, and yet trying to look as important and as imposing as possible, Monsieur Pierre summoned me over and asked to see the Polaroids of the morning's shoot.

He mumbled his appreciation and leeringly made some remarks to Claude.

Then it happened, the moment that I had dreaded.

"The envelope," He tossed his head, as if pulling me towards him, "the money, you have my expenses?"

"No," I replied. "I have been up since 4am this morning and I have had no chance to get to the bank."

With that he demanded a glass of Chardonnay from Geoff, who had previously packed a cooler box under strict instructions from Brian, his boss.

I turned away. I had managed to avoid the payment. I was determined to hold out, for how long I didn't know. I would take it as it came. I had good excuses, up every day at the crack of dawn and not getting back to the hotel until seven at the earliest each night, sometimes nine.

I was walking on a treadmill, up early each morning and very late to bed because Monsieurs Pierre and Claude demanded belly-extending gourmet dinners every night. Even Brian was getting exhausted by the lavish dinners and the early morning starts. Of course, Monsieurs

Pierre and Claude would only show-up the next day around 11am on the beach. They'd plonk themselves down in their director's chairs and then, fuelled by another ice-cold bottle of Chardonnay, make some remarks about the Polaroids and promptly fall asleep until lunch. We (Brian, Geoff, the models and I) would move to the next location, snatching a sandwich on the way, whilst Monsieurs Pierre and Claude would indulge in a light lunch. Pomme frites, steak Béarnaise, salad, cherry or apple tart and cream (sometimes both) and cheeses. Washed down with a bottle of wine (sometimes one each) with every course. Half the days they would show up at the afternoon's location. The other fifty percent of the time they never made it.

But there they would be in the evening, raring to go, to the next gastronomique blowout, or a trip to Monte Carlo.

"Do you know La Colombe d'Or?" Monsieur Pierre challenged (as if to say, I doubt that you know La Colombe d'Or), "I'd like to go there". He then chucked in the word 'tonight'. For added impact.

"Yes, er, I have heard of it," I replied, raising an eyebrow. Monsieur Pierre may have noticed it, but I doubt it.

"Get us a table," he demanded. It was, I remember, about 8.30 at night.

Now, La Colombe d'Or is, as Monsieur Pierre made it perfectly clear, one of the finest restaurants in the region…no…in France…no, in Europe. Fuck it; it was the very best in the world. It was, and still is, one of a kind. A feast for both educated eyes and educated stomachs.

North of Cannes, in the mountain village of St Paul de Vence, this was the spot where the likes of Picasso and Matisse dined and, literally, painted for their dinner, donating their works of art as payment. Hey, where else can you dine amongst the great masters? You are literally rubbing shoulders with the art, not only Picasso and Matisse, but also

the art of the great Romantics and early Modernists. Chagall and Braque dined here and, when you dine, you dine in front of a mural by Fernand Leger too. The place is, I think it's fair to say, littered with art. On the walls and in the garden. The legacy of the starving artists of the time is everywhere. I seem to remember there was even a fragment of white tablecloth signed by Picasso. What was that worth when he originally signed it? A glass of wine? A whole five-course meal? Today, you could probably buy a whole vineyard with it.

These days you are, of course, not rubbing shoulders with the artists, but such is the history and allure of the place that you are touching elbows with Parisian celebrities, and the nouvelle riche – 'Les Snobs' (Did you know that 'Snob' is actually a French word? Go to Paris and see why it is so painfully apt!).

Anyway, this altar of art and haute cuisine is a Mecca for art and food lovers and much sought after, in or out of season. Consequently bookings had to be made months in advance.

So, 'Get us a table' was not only a command, it was also a swipe at my ability to pull off the impossible. And it was Monsieur Pierre's chance to get back at me for not delivering the brown envelope. He would belittle me in front of everyone.

He tossed his head in the air and, with a satisfied snigger, looked at his audience, Brian, Geoff and Claude. Claude stood there shaking his head, 'Never in a month of Sundays, will Aubrey pull this off.' You could see the sublime pleasure on his gluttonous face.

"I have the table Monsieur Pierre; it's booked," I said.

Well, you could have heard a pin drop. An incredulous look pervaded Monsieur Pierre's bulbous face. His eyes did a little 'cartoon sweep',

Monsieur Pierre challenged me to book a table where the great artists gathered including Picasso, at La Colombe d'Or!

moving quickly from side to side, as if to rattle and jiggle his brain. Had he heard correctly? His eyes stopped, looking straight ahead. Transfixed. He raised his eyebrows and smiled. Just very slightly. And then, very slowly he shook his head.

The journey up into the hills was, as they say, uneventful. I felt an inner calm, a sense of sneaky accomplishment and anticipation of what lay ahead.

The car drew-up and Monsieur Pierre's door was opened by Claude. Brian, Geoff and I squeezed out from the back seat.

Monsieur Pierre could hardly contain himself and strode on ahead, to be halted by the maitre'd.

"You have booked?" He enquired of Monsieur Pierre, as he raised his pen to tick off the name in the ledger and then, looking up, a broad smile spread across the maitre'd's face.

"Ah, Monsieur Malden," the maitre'd caught sight of me behind Monsieur Pierre, "Monsieur Malden, welcome back, how are you, we haven't seen you since, when was it…?"

"I am well," I replied, "Thank you for fitting us in."

I then introduced our party, Monsieurs Pierre and Claude first of course. Then Brian and Geoff. The maitre'd was overflowing with charm and was, indeed, most courteous. He nodded at each introduction and interspersed several 'Welcomes' at the appropriate time. With a few 'Most welcomes' for added impact…all the time moving us slowly to our table, set for five.

Monsieur Pierre stood there open mouthed. Catching air like a fish gasps for breath when pulled fresh from the water.

The open and airy ambiance brought many thinkers and artists,
including musicians, to the tables of La Colombe d'Or.

He was just nonplussed. Incredulous. How did this Englishman know the place in the first place? And how did he know the staff so well?

He could hardly restrain himself. Neither could I. I gestured to the wine waiter to come over.

"You eat here often?" Monsieur Pierre tentatively enquired, as the Carte du Vin was handed to me by the waiter who also nodded and smiled in recognition.

"When I'm in the area," I replied.

"Oh, I see. And when would that last time be?"

"Oh, a couple of weeks back. We ate here, I think, three nights in the

week. Just wonderful."

This certainly put Monsieur Pierre back into his box. He was unusually quiet at the dinner and he didn't hold his normal 'court' either. He even forgot to order the cheese.

Today he still doesn't know what happened. Unless he is reading this book.

And this is what did happen…

By some remarkable coincidence, about two weeks earlier, we had a

contact@la-colombe-dor.com and say 'hello' to the art of food and the finest of service

European Creative Director's Conference in the area and eager to stretch our legs (and get away from hotel food) we ventured out, almost every night. One of the Creative Directors from London, whose name escapes me now, knew of La Colombe d'Or. I think he had indulged himself when he attended the Cannes Film Festival the year before.

He had booked the restaurant for those three nights and each night one of us would take care of the bill. As it happened I was the only one who spoke French of any quality in our group of around twelve. My French was bad and still is (actually far worse now) so I ended up helping out both waiter and guest with translations, as best I could. And some of the translations and pronunciations had the waiters in stitches.

Nevertheless we drank well, ate well, laughed a lot, perhaps more than we should have done in such a shrine, and we stayed late. And, of course, we tipped well.

Anne Marie, Account Executive, Rosette, an Account Director and me, at one of our many awards dinners, shortly after the "Tarts & Brown Envelope" scenario.

So, when I phoned to make the booking for Monsieur Pierre, I reminded the maître'd of our visits and he replied, "Who could forget them?" and insisted I spoke English to him! He would make a special point of remembering me, as I had asked.

Got you Monsieur Pierre! Got you!

Until Brian got me the next day.

"Now he wants women," said Brian. "He is driving me wild with his constant nagging. Just get him a woman. I'll pay. And get one for Claude too."

Ah ha! Remember I said having an underwater photographer for an on-land shoot didn't compute? Well, now it did. Brian was paying Monsieur Pierre for putting the work his way. Six days in the South of France was no cheap shoot. He'd probably already paid a cash back-hander for it, now it was his turn to pay again, this time with flesh.

"You get the women Brian. You got yourself the client, the shoot, the mess, and now the problems. Don't pass it all onto me. I don't do this stuff. You do it Brian. I won't."

Quite frankly, I had had enough. This endless binge was overshadowing the reason for us being here. To create a campaign for Monsieur Pierre's popular brand.

So, I refused to budge and we left it at that. Until lunchtime.

"He's driving me wild like some fucking child wanting a toy," said Brian.

Brian was beginning to lose his cool with Monsieur Pierre. He was tired too. Exhausted by the meals and the work. He was sweating over this latest issue; he had been given the hottest of potatoes. Find Monsieur Pierre a woman. As he stood with me pleading, the sweat oozed and

They say the main ingredients of the cuisine is sunshine. The private dining room seats thirty, where the walls are thick with art.

dripped and his spectacles slid down his nose and then he prodded them up again.

"Please, just get them a fucking woman!" he screamed.

"You do it Brian."

"But I can't speak a word of fucking French."

"Brian. It's your shit. You sort it."

"Please, Aubrey. I can't go on like this. Get him, get him a fucking woman."

His shapeless British body tinged with sunburn was now turning a different colour. Yes, it was puce. Brian was puce.

"OK, OK. Calm down. Don't get your knickers in a twist."

Brian looked like a condemned man who had just had his sentence reprieved.

Now, if you do decide to skip a few pages and fast-forward this chapter, I won't blame you; after all, you bought the book, or borrowed it (if you stole it, give the book back and go and buy your own copy to keep the sales up!) But whatever you do, bear a thought for the author; much of this may now seem amusing, but at the time it wasn't at all amusing. It made me very angry. The way I tried to twist and maneuver the endless, demanding days into moments of opportunistic fun were my way of lessening my anger. Consequently, the days became a series of games. They certainly tested my morals. And quite frankly I would have loved to have skipped a few mornings, or nights, or whole days, as quickly as you can skip the pages now.

"I'll sort it." I promised.

"When?" said the desperate Brian.

PANTONE®
184 C

Pantone 184 C. The colour of Brian, puce.

"Tonight. I'll sort it tonight." I said.

That evening the shoot finished earlier than usual and I took a stroll with Brian into the back streets of Cannes. A stroll into the 'Red Light District'.

"Look Brian," I explained, "we are Brits and I don't do this sort of thing. Neither should you. So, I am going to get Monsieur Pierre a woman, but not the sort he is expecting. Something a little different. This woman is going to be an unforgettable experience for him. He will never ask anyone for a woman again."

I had never been into one of these places before. I must admit to being doubly embarrassed. First the place was very seedy, smelling of cheap perfume and Gauloises and, secondly, my French had never been tested in this area of vocabulary before. I knew how to order a bottle of wine, find the way to the train station, and buy a pair of trousers but, to buy a woman? Never.

Fortunately, the man, amused by my embarrassingly bad French searching for the right carnal word, took pity on me and switched to a very proficient English, explaining that they had many English sailors looking for the same sort of woman as us. He knew just the type.

The man pointed to the top shelf, "That's the one you want, sir. She's the most expensive. Helga. She has French underwear, firm bosoms and is, how you say, is most obliging in, er, every 'trou'- how you say in English? Hole!"

He pulled her down from the shelf with one of those long wooden poles with a hook on the end.

Brian paid the money and we were off. Off with our new companion. Helga. Helga in a box. Yes, you got it, the most expensive inflatable woman we could find in Cannes was now accompanying us into the

foyer of one of the most expensive five-star hotels in Cannes.

"This is the plan, Brian…"

After a few aperitifs in the hotel bar, we had a great dinner with Monsieurs Pierre, Claude, Geoff and Brian. Monsieur Pierre was very jovial and relaxed, a little more than usual. The wine flowed and, to end the meal, he had a good digestif, a rather well-rounded cognac. One that you don't find that easily, even in France. So rounded was it, that when I proffered another Monsieur Pierre greedily accepted and had just one more too, 'pour la route'.

We retired to the bar as Monsieur Pierre felt like puffing on a Romeo Y Julieta cigar, whilst smacking his lips at the thought of hitting his taste buds with another well-rounded rare, and of course, expensive cognac.

Finally, and eventually, well fed, and rather well 'watered', it was time for bed.

"We have a little surprise for you," said Brian as Monsieur Pierre sipped and savoured the last of his cognac from the oversized balloon glass. "You wanted a women, and she," Brian glanced at me a touch nervously, "well, she, she is waiting for you, in your room."

"Oh," said Monsieur Pierre, "oh!" Like an excited child about to open a present knowing what was inside.

"Ch…champagne and t…t…two gglglasses," he giggled, slurring his words encouragingly, and then he slid off the bar stool, managing to stand but swaying at the same time.

"Oh!" he said again, as Brian and I guided him towards the lift and his suite on the fifth floor.

As we escorted Pierre to the lift, I cast a glance back at Claude. 'The

boss gets all the perks', I'm sure he was thinking.

The lift doors closed with a rumble and a gentle slam as only those old lift doors can. We creaked our way upward. Brian smiled, I smiled back, and Monsieur swayed and closed his eyes. Too much drink? Absolutely. And a wicked thought or two, besides!

"Hmm," Pierre grunted to himself, and smiled.

'Ting', the bell signaled our arrival at the fifth floor, the doors trundled back and Monsieur Pierre stepped out, first to the left, corrected his list to port, leaning and suddenly weaved to right.

He was on his way, champagne bottle grasped by the neck in the left hand and the two glasses held by the stems in his right; he walked and shuffled, in a reasonably controlled manner, to his suite. A satisfied grunt and chuckle accompanied him.

Brian and I turned in the opposite direction and made our way to our rooms, arriving at our doors before Monsieur Pierre reached his. We stopped and fumbled for our keys whilst both taking sneaky looks to the right as Pierre set down, first the bottle, and then the two glasses on the carpet outside his suite. He searched for his keys first in his right-hand trouser pocket, then the left. After a moment's search his hand came out of the pocket and he triumphantly held the key aloft, holding it proud from the safe and bar key that he also had on the same key ring. With a double grunt of satisfaction, and an 'a ha!', he aimed the key at the lock, and missed. He tried again and the key went in. He turned it with his right hand and reached down to pick up the champagne bottle with the other; then he gently bumped open the door with his right knee and, as it swung open, he scooped up the two glasses with his now free right hand and tottered in to his darkened suite.

Brian and I looked at each other and waited.

We positively exploded with laughter, we held our bellies, we held everything

"Mon Dieu!" You could hear the cry from our end of the corridor. Then the thud of the champagne bottle as it hit the floor quickly followed by a resounding pop as the cork exited the bottle, followed by a hiss, as the champagne spurted out. There was a moment's silence and then we heard the tinkle of the two glasses breaking on the floor and then another, "Mon Dieu!"

We rushed down the corridor and into Monsieur Pierre's living room. From there you could just see, forty-five degrees to the left, into his bedroom. The door was ajar. The same cheap perfume we had smelt in the shop hung in the air.

"Murder, help! Murder!" Monsieur Pierre was standing in the middle of his living room, wet with champagne and absolutely transfixed. He stepped forward and frantically flicked all the light switches, not one light came on.

We followed his gaze to his large mahogany double bed. It was dimly lit by one bedside light. In his bed lay a female figure, motionless and stiff.

From a distance it looked as though the woman had been stabbed, mouth open very wide, like she was desperately shouting for help, blood, and lots of it, it seemed, surrounded her open gasping mouth.

"Help! Help me," pleaded Monsieur Pierre. "She's been killed."

Brian positively exploded with laughter. Tossing his head back, he just roared. I did too. We sniggered, we laughed, we held our bellies, we rolled on the floor, we wheezed, we became breathless, we stood up and we sat down. We held our chests, we put our hands behind our heads supporting them as we felt they might fall off, we wheezed again and tried to stop the laughs. We just couldn't stop. Real uncontrollable laughter, eventually really hurts — you sit down and then stand up and finally it stops. You have to stop; otherwise, as they say, 'your sides would split'.

"What? What's going on?" said Monsieur Pierre.

Brian walked over to the opposite side of the bed to where the woman lay and put his hand down into the lampshade. There was a gentle squeak as Brian screwed back the bulb and then a simultaneous glow as the contacts from the bulb had electricity flowing through them again. I balanced on a chair and, reaching up, I put my hand into the bowl of the art-deco shade and tightened the bulb. It too, came to life.

"Voici!" I said, and jumped down and with a dramatic sweep of the arm pulled back the sheets from the bed.

And there she was, Helga, now well lit, in all her glory.

It was a horrible sight. Helga, legs wide open, arms wide apart and a monstrous mouth, open and gasping.

Brian and I had carefully lit her earlier, by removing all bulbs in the bedroom from all electrical contact, save the one to Helga's right, the one in the bedside light. It was this light, with the aid of a small fluffy towel from the bathroom, that cast the ghastly shadow across her face and lit her lips just enough to make them look like they were gruesomely covered in fresh blood that had gurgled up from her punctured lungs below.

Monsieur Pierre was anchored to the floor. Brian and I weren't sure what would happen next. Then it happened. He burst out with an uncontrollable roar...of laughter!

We were both very heavily relieved.

As it was, Monsieur Pierre was also relieved, relieved that it wasn't really what he had imagined was in his bed: a Cannes prostitute somehow slain before she could do her duty with him. Stiff and dead in his bed, in his suite, in a five-star hotel, in Cannes. The publicity would be most damaging to him.

We all looked at each other and gazed down at Helga. Have you ever seen one of these dolls? Do people really do 'things' to them? What, in all three holes? Arms spread wide apart. Legs apart, the word is, I think, prone. And the breasts? Have you ever seen breasts like this? Conical ones (and absolutely comical ones they were too), two extra elements stuck onto the fully inflatable figure like two additional inverted fat ice-cream cones with a single cherry on the end of the pointy bits.

She was the most expensive 'girl' in the shop? Hey, imagine what the cheapest one would look like!

"You boys! You are so naughty," said an exhausted, wet, and still slightly tipsy Monsieur Pierre. "You and your British sense of humour, so funny…" He sat down on the bed and sighed, mopping his brow, and his champagne soaked trousers, with his handkerchief.

"Come on Brian, let's get her out of here, we'll take her back to my room," I said, as I picked-up Helga (no pun intended), shoving her, head first, under my right arm, her arms pinned to her sides, her legs sticking out and dragging behind me.

I peered round the door of Monsieur Pierre's suite and, seeing the coast was clear, took Helga to my room.

Incidentally, have you ever tried stuffing a fully-inflated, full-size female doll into a cupboard? Unless you somehow squeeze and push her all in, all in one go, the arms sort of spring out from her side and whack you in the face with a squeak and 'thwock!' It's not painful, just a little annoying and somewhat embarrassing that an inanimate object can do this to you, especially as you just want to flop into bed. Anyway, after several squeaks and two 'thwock, thwocks,' from both arm, and, then, an outstretched inflatable leg in my groin, I got Helga safely stowed away. And I, to bed, smiling. We had won one over on Monsieur Pierre and I think we charmed him with our very 'British sense of humour', or

embarrassed him with delivering a woman, but of the wrong variety. I don't think he would dare ask us again, for a woman. No sir.

The next morning, with Helga safely stuffed into my cupboard, I made it down to the foyer for our 5am rendezvous with Brian, Geoff and the models. Monsieurs Pierre and Claude, as usual, were nowhere to be seen.

"Um, Monsieur Pierre wants a woman," said Brian after lunch. "Although he said he was very, very amused at our little antic last night, he is very, very serious about wanting a woman. One for him and one for Claude. Tonight." He added hastily.

He was certainly tenacious about his requirements, I thought. I was seriously mistaken about us winning one over him then. What's more, I hadn't a clue where to find a woman for him and another for Claude.

So, that night after an early 7pm shoot wrap, Brian and I went back to Helga's original home, the shop, and sought out the kind gentleman who had introduced us to squeaky, 'thwock, thwock,' Helga.

He was playing with a dildo, rather absent-mindedly I thought. Holding it in his right hand and rubbing it into his cupped, left hand. He was bemused as it bent, twisted and purred. Perhaps he was wondering what it felt like to be a vagina, with that thing whizzing and whirring around inside you, or maybe it just helped him relieve a touch of arthritis, who knows?

When he saw us he put it down on the counter, forgetting to switch it off, so it buzzed around on the wooden surface, a bit like a very fat bug that's been sprayed with fly spray and was refusing to die. It edged towards the counter's lip, and, as it was about to tumble over the side, and continue its death-throw buzz on the carpet below, I grabbed it (by the handle end, I must add) and, switching it off, I placed it on the counter, upright, like the sword of Excalibur.

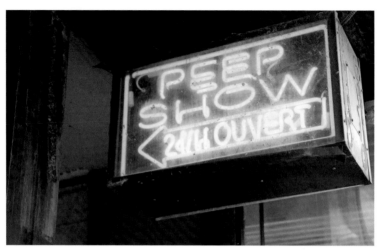

Monsier Pierre wanted a woman. So I looked for one of the right calibre.

Whilst Brian wandered around the store picking-up the occasional toy and wondering what it was, what it did and who it did it to, I got directions from the shopkeeper to a strip joint down the road.

The big bouncer at the door, who smelt of red wine, showed us into the musty and darkened club which appeared to be an old cinema. It was no larger than a couple of badminton courts. The original seats were still in place and a show on the little stage where the cinema's screen would have been was just finishing. A small and fit, slightly cuddly girl of around nineteen, wearing sparkly and scanty knickers, was putting away a snake in a box, whilst a larger girl, probably around thirty, totally naked, was wrapping her body in a 'peer-and-you-can-see-everything' diaphanous red shawl. The dozen or so men in the audience clapped, half-heartedly, some whistled, some said things in French that I didn't understand but were obviously rude. One reached forward and made a grab for the girl's shawl and was kicked firmly back into his seat.

We were shown to the back room and introduced to the two girls, still

'dressed' in their stage clothes. It was odd having a conversation with them dressed like that. Two sets of breasts and furry bits displayed. Odd for us, perfectly normal for them I suppose. After a few pleasantries, during which we discovered the cuddly one was a student and the other a mother of two children, we quickly got down to business.

"So," I concluded the deal, "you will come to the hotel tomorrow night with three other girls, have dinner with us and two other men (we didn't give their real names, nor ours either) and you will then put on a little show for us all. After the show, the three of us (Brian, Geoff and I) will leave with three girls whilst the other two will stay behind with our two clients."

The deal was agreed and so was a strict tariff too. So much money for the basic dinner and dance, as it were, and then a scale of charges that ranged from well, fondling to fucking (in a number of stipulated ways). Spending all night with our boys carried an extra levy. They didn't want more than a small deposit to cover the dancing and the taxi fare to the street behind the hotel (which we paid over then). As for the balance, well, they knew where we were staying and the bouncer was a good friend of theirs.

That night we apologised to Monsieur Pierre and Claude for not being able to get two girls for them that evening but said that we had managed to arrange a 'special' for the following night. We explained what was to be on the menu and that they must have whatever took their fancy. We (I was not going to pay a penny, it would be Brian paying for the lot) would foot the bill.

Placated and excited, Monsieur Pierre and Claude ate and drank well.

After the photo shoot the next day, Brian and I got back to the hotel, showered, shaved, and changed into our dinner and dance clothes – chinos, sports shirts and deck shoes.

Before we left to collect the girls, I reminded both Pierre and Claude that they must not tell the girls their real names, nor tell them who they worked for, what they did and where they came from. Just in case. I had read in books (or had I seen it in a film?) that, sometimes, 'these sorts of girls' do use the occasion to blackmail their clients.

We collected the girls , who looked suspiciously like 'all trench coat and no knickers', from around the corner of the hotel and marched them quickly past the doorman who, contrary to my nervous expectations, didn't bat an eyelid. It was, it seemed, perfectly normal. In France, on the Côte d'Azure, of course.

We ushered the girls into the lift and we were off and upwards to Monsieur Pierre's hotel suite where a table had been laid for eleven. Monsieurs Pierre and Claude, Brian, myself and Geoff, our five girls and, at the head of the table, with her back to the door, a special guest, in dinner jacket (no shirt, nor trousers) and black bow tie, Helga.

The five girls looked at Helga, but said nothing. They must have imagined everything though.

To relieve the tension Geoff and Claude poured champagne and the room service menu was passed around. Lobsters, smoked salmon, salad Niçoise, gateaux and cheese were ordered. Along with wines from the Loire, dessert wine and port.

There was a sharp tap at the door accompanied by 'Room service!' and the sound of the preparatory maneuvering of the trolley outside the door.

"Come," commanded Monsieur Pierre, who was seated at the far end of the table facing the door to his suite, Helga facing him at the other end.

There was a rattling of keys, the lock was turned and the door opened

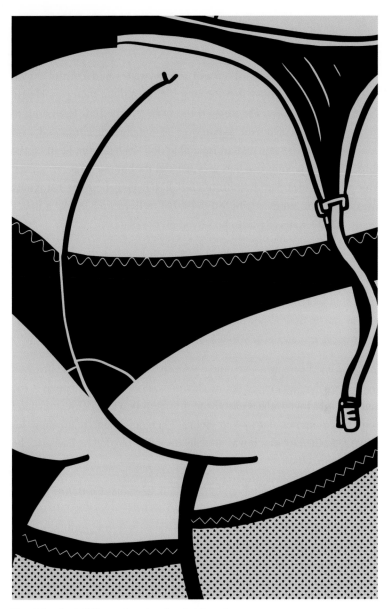

The girl arrived, "All trench coat and no knickers."

with a gentle bump as the trolley, laden down with food and wine trundled in.

"Monsieurs, Mesdames," the room service waiter nodded and smiled as he wheeled the trolley first through the open door, then past Helga. He did a double take. He stopped the trolley, turned his head and, in an instant, a look of horror spread over his usually well–composed, five-star face. What he saw was an inflatable doll sitting at the head of the table. Breasts poking out between her tightly buttoned dinner jacket. Her mouth wide open. A knife and fork had been gaffer-taped at ninety degrees to her hands resting on the table in front of her, like a navvy ready to eat whatever was to be served on the plate.

He hurriedly wheeled the trolley past the left-hand side of the table and came to a stop behind Monsieur Pierre, "Shall I serve sir?"

"No, that won't be necessary, thank you very much." Monsieur Pierre said it slowly and somewhat pompously, which seemed to unease the room service waiter even more.

After he had been dismissed, and obviously relieved from being involved in any possible bizarre goings on, the room service waiter stepped to the right of the table, walked past those sitting on that side of the table and took one more nervous look at Helga. Then, as though reaffirming his worst fear, the fact that it was actually an inflatable doll he had seen, he was gone in a flash.

Monsieur Pierre chuckled out loud. I think he rather liked the idea that Helga, who had fooled and startled him two nights previously, had now caused considerable consternation with the waiter from room service. The dinner was tense and polite. A lot of small talk, pregnant silences and unease, reminding me of a time when I had dinner with the parents, whom I didn't like, of a girlfriend that I did like, a lot. I just wanted to get it over with and then get on with the rest of the evening — a cosy

kiss and an adventurous cuddle — when the parents had gone upstairs.

It was the same here. Get the dinner over. Have the show, and then get on with what Pierre and Claude had asked for: sex.

When the dinner was finished, we moved down the suite into the more comfortable sitting area. The five guys sat on the two couches. Brian, Geoff and I sat on one and Pierre and Claude on the other, hands clasped and legs crossed, attentive, both looking as if they expected someone to read them a story.

I signaled to the girls to start their show. Four of them went into the bathroom to change whilst the older one, the one we had met in the club, knelt on the floor with her small ghetto blaster.

She pressed the start button with a click. Pierre and Claude looked at each other and combined a smirk with a smile.

Two of the girls entered the room, twisted their bodies around a bit, untied their bras and then did that thing when they take off their G-string and pull it up and down, from front to back in a sawing action. Then they twirled it about in the air, finally letting it go, to land where ever. In this case, one landed on Claude's face, the other on the floor in front of Pierre.

It was all a bit quick and mechanical. They just went through the motions, I thought. But clever motions they were too, in places. Both managed to contra-rotate their breasts, as they moved their hips in time to the music. One set of breasts were large and slapped each other as they met in the middle and the others were, well, quite tiny and pert and therefore refused to swing and gain momentum, so she had to give them an extra jerk from time to time to try and set them in motion. As it was, the motion didn't last long and she would have to give them another jerk to get them going again.

The two girls tip-toed into the bathroom and then, after the women in charge of the ghetto blaster had played a few seconds of the wrong track, the two other girls appeared. I couldn't really distinguish this act from the other. The same contra-rotating breasts but, this time, each pair of breasts were of medium size so, consequently, there was less slapping of the breasts for, as they swung, they rarely met in the middle. However, the girls seem to want to compensate for this by slapping their own bottoms instead. Then, pausing for a moment, with a very staged look of naughtiness, they coyly popped the tip of their index fingers into their mouths. Then they took them out and ran them down their noses, across their lips and then licked them with their tongues.

The G-strings came off in the normal manner and were about to be tossed in Brian's, Geoff's and my direction, before I caught the eye of the taller blond one, indicating they should toss them in the direction of Pierre and Claude instead.

So, they twirled them a bit more and eventually, when the music reached its crescendo, they tossed them gently into the air. One landed partially in Pierre's glass of champagne and the other went skywards and hit the bowl of the art deco lampshade with a 'ping' and hung there, swinging, with the tiny sequins glinting in the light.

The dancing was over. That was it. Now we waited, with bated breath, to see what happened next.

Previously I had briefed Monsieurs Pierre and Claude that, when the dancing was over, they must indicate which two of the five girls they wanted to stay behind. Brian, Geoff and I would then leave with the other girls as soon as possible, leaving them alone, free and able to get 'on' or 'down' to business, which ever they preferred.

Monsieur Pierre caught the eye of one of the girls who had been in the second dance routine, let's call her 'Miss Firm Breasts', whilst Claude

**we waited with baited breath to
see what happened next**

patted the cushion on the sofa next to him indicating that 'Miss Non Rotator' from the first dancing session should be his.

Immediately after this team selection had been made, Brian, Geoff and I made a move to leave with the three other girls, but Monsieur Pierre spotted our attempted early exit and insisted that we must stay for another glass of champagne.

"What are you doing here and where do you come from?" enquired Miss Firm Breasts of Monsieur Pierre. I froze. Oh my God, she's asked the question I didn't want to hear and I certainly didn't want to hear what came next either. I was sure Monsieur Pierre would answer, 'Oh I am the Chairman of The Company and we are here making photographs for an advertising campaign'. I was frantically trying to catch the eye of Monsieur Pierre, to remind him not to give truthful answers, when his eyes caught a glimpse of Miss Firm Breasts' breasts, and became transfixed. He looked at them like a child looking down a garden well, wondering when the stone he had dropped into the well would reach the bottom. Maybe he was imagining what he might do with them once they became 'free range' and, in that mesmeric state, he simply said, "My dear, you may call me Pierre."

It couldn't get worse, could it? But egged on now Claude spoke-up for himself too, "And you," he poked a finger into Miss Non Rotator's shoulder, "You may call me…" I waited for the answer, Brian waited for the answer, Geoff waited for the answer. 'Go on Claude', I was thinking, 'she can call you, Joseph, Albert, Siegfried, Roland, Superman, Cassa-Bloody-Nova. Anything but Claude'. "You may call me.." he completed the sentence, "…you may call me, Monsieur." 'Good on you Claude', I thought, 'well done; at least you've kept your identity and possibly your integrity intact'.

"Another glass of champagne, girls?" said Monsieur Pierre, and then to complete the mess, he added, "and you Claude?" 'Oh shit that was it', I thought, 'why not hand over your business card and private addresses and telephone numbers, the name of your wife, then show them a picture of the whole family and point out your two children named Susan and Robert...?'

This was a catalytic moment for, at that point, the plot was definitely lost. I saw Pierre pick-up the Polaroid camera, hand it to Geoff and ask for, 'a memory of the evening, if you please'. The camera whirred a few times and spat out three Polaroids.

As I left I managed to bend Claude's ear (actually I almost bent it in two) warning him to destroy the photographs at the first possible opportunity.

"Now Monsieur Pierre, you naughty boy, what shall we do next?" said Miss Firm Breasts as Brian, Geoff and I slid our way out of the suite. The next morning was a later start than normal as we were going to photograph the models at a small café up in the mountains and were only going to start shooting at around four in the afternoon. We planned

The Polaroid camera whirred into action. It was a silly mistake.

to leave around 11am and now it was 9.30am, so breakfast was relaxed and happy. Very happy.

We were especially happy because we (Brian, Geoff and I) had got to bed reasonably early, for when we had exited the suite we immediately took the three girls down to the lobby and got them a taxi home (Yes immediately, although I think Geoff would have liked 'his' to have stayed).

We were extra happy because eventually we had got Pierre and Claude exactly what they wanted. Exactly what they had pestered us for, for several days: two woman. Real women, not inflatable Helgas, but real women with proper breasts and real holes. And all costs were covered (by Brian) so they could, as we briefed them, 'do what you want to do (within reason) and just let us know what it was that they did to you and you did to them, so we can pay the girls the right amount according to the agreed tariff.'

And here they were too, two happy, smiling men arriving at breakfast, at the unheard of hour of 9.45am. They were walking on air. They smirked, smiled and purred, and they thanked us profusely.

"How was it?" asked Brian digging for detail.

"Fantastic!" said Pierre. "Superb!" he added underlining and leaning on the 'b' of 'superb' like only the French accent can do.

"Incredible!" added Claude.

"So naughty, so wicked, so…. nice, memorable, unforgettable, fantastic. Fantastic!" they competed with each other, searching for the most explosive and expressive adjectives. Interjecting the 'incredibles' and the 'fantastics' with, 'oh la la!', and that French sexual signal of strength, the gesture where the right arm is bent upwards at the elbow and, simultaneously, the left hand is placed on the right bicep as the right fist

is moved at ninety degrees, towards the right shoulder – a gesture of the penis rising, is it not?

Embarrassed to ask exactly what they did and how long they did it for, we presumed, as it had been the very best for them, it would be the very worst for Brian, for he was to be in for a hefty bill from the girls. Top of the tariff we thought. After working out an hourly rate and the various possible positions that gave the various price options, Brian asked Geoff to go to the bank and draw out extra cash in addition to what he had already calculated. After further expressions of delight and ecstatic thanks, at sporadic moments during the day, from Pierre and Claude, Brian made a recalculation and again sent Geoff of to the bank, 'Just to be safe.'

The shoot in the afternoon now seemed incidental. My thoughts turned to the evening. All that mattered was paying off the girls. So as soon as we got back to the hotel Brian and I, accompanied by Geoff, started out on the walk to the club. Nervous, and checking over our shoulders from time to time, as we were carrying a large amount of cash stuffed down Brian's trousers, we actually made it to the club in about ten minutes although it seemed somewhat longer. A lot of bystanders were watching us ready to whack Brian and run off with the girls' money, or so we imagined. Finally, we were greeted by the big bouncer at the door, with the 'red-wine breath'. He showed us to the back room, where the five girls were waiting in various stages of dress and or, undress, depending on how you looked at such things.

Once again it was, or seemed to me to be, very surreal. Three guys in a small back room which smelled of Gauloises, glowing women and stale perfume, with five partially clad women about to have a conversation about, well it could have been about cricket the way we all sat or stood around. But no, we were there to have a conversation about the sexual performances, proclivities and preferences of our two clients

the previous night, in a suite, in a five-star hotel, in one of the most affluent and extravagant cities in France, all of which had been dumbly witnessed by Helga, an inflatable doll.

Brian took the wad out from his trousers and began to put the individual bundles on the dressing table. He sweated, his glasses traveled down his nose, he pushed them up again, took a drag from his cigarette and set the cigarette down in the ashtray. The smoke curled up and joined the rest of the haze from the Gauloises that the girls had previously exhaled.

He put a second bundle of money on the table.

"How much do we owe you then?" I said it in English, so Brian could get an idea, when the answer came, of exactly how much he would be coughing up. His hand hovered over a couple of bundles. With Monsieur Pierre's and Claude's ecstatic, 'Fantastics,' 'Incredibles' and 'Oh la la's' still ringing in his ears, he was already anticipating the placement of a third bundle.

Miss Firm Breasts took a deep suck on her cigarette, raised her eyes, blew a long, thin stream of smoke to the ceiling and then, fixing me with a very firm gaze, she smiled and said, "Rien."

"What?" I said, absolutely dumbstruck. "You mean…rien, nothing, we owe you, nothing?"

"Nothing?" Brian echoed questioningly, "There must be some mistake?"

"Oui, absolutement rien!" repeated Miss Firm Breasts.

The other four girls shrugged their shoulders, shook their heads and said in unison, "Rien, rien, rien."

"But, why?" I asked. "He said it was fantastic, Claude and Pierre said it was fantastic."

"Because, well, after you left, do you know what happened?" said Miss Non Rotator.

"He said it was incredible?" interjected a puzzled Brian.

"Well, it was incredible," said Miss Firm Breasts, "Incredible because…."

"Because…," continued Miss Non Rotator.

"Because of rien," said Miss Firm Breasts. "Nothing happened."

"Explain," said I.

Then Miss Firm Breasts told us that Pierre and Claude had sat the girls on their laps and they sipped from each other's champagne glasses. Pierre gazed at Miss Firm Breasts' breasts and Claude put his hand on Miss Non Rotator's knee.

"And?" I said, encouraging the story to go further.

"It went no further," said Miss Firm Breasts. "Oh, we talked and talked and drank more champagne but I think they were scared."

"Scared?" I asked, "of what?"

"Well, how you say in English? All talk and no panties?" Miss Firm Breasts said in her best English accent.

I corrected her, "All talk and no trousers, you mean?"

"Yes. All talk and none of the trousers," Miss Firm Breasts affirmed. "We said they could have a good time with us and they said they were having a good time."

"We said they could have a really, really good time with us," emphasised Miss Non Rotator, "but they just bounced us up and down on their knees and made little talk."

"IT WAS ALL TALK AND NO PANTIES"

"Little talk?" asked Brian.

"Small talk, I think she means," I said to Brian.

"Small talk, little talk, no action," said Brain somewhat irritated. "All that money and nothing bloody happened. A waste of time and that deposit I paid. Just for a dance and a gaze at some spinning tits!"

"We stayed for about another forty minutes and then we left." said Miss Firm Breasts.

'So', I thought. 'So, they got cold feet and wanted to carry the whole masculine thing off. They came down the next morning both feigning great exploitations. Sexual prowess. Conquistadors in Cannes. But they were in fact just the two fat wallies, the 'Wallies from Walloon'.'

We thanked the girls for the show and their honesty, after all we could have ended up paying more if we had believed the innuendoes of the guys. Thank goodness there are still such honest girls.

We owed them no more than the initial deposit. And we decided to save face; we would not reveal to Monsieur Pierre and Claude that we had learnt what had actually happened that night – that nothing had actually happened and we carried on as though the two of them were right stallions.

On the last evening of the shoot, we descend from the fourth floor to have a final pre-dinner drink at the bar. The lift door stops with a jerk and a 'ping' as the bell signals the unscheduled stop at the second floor. The doors trundle open and a well-dressed, middle-aged man steps forward to enter the lift. Brian, Geoff, Monsieur Pierre, Claude and I are standing in the middle of the lift unintentionally blocking his way.

"Monsieurs," says the guest greeting us.

We moved to the sides of the lift to make way for the guest.

"Merçi," he says, as he steps forward. The 'merçi' was instantly followed by a gracious nod and a, "Madam."

Then he froze for, facing him, yes, there she was, Helga. Respectfully dressed in white wing-collar dinner shirt, hand-tied bowtie, soapstone cuff-links, dinner jacket and trousers, patent leather shoes and socks. A very respectable sight she was too. One that befitted a classy five-star hotel in Cannes. Except that her arms stuck out from her sides at ninety degrees in a welcoming and hug-me-like manner. And the mouth, yes that mouth, was wide open, gapping like a gold fish, and the lips still that shockingly bright red!

We looked back at the guest as though this was a perfectly normal sight. Monsieur Pierre gave a reassuring smile and a gentle shrug of the shoulders. The gesture said it all, 'Good evening sir, all is OK, don't panic sir, we are not escapees from the local looney bin, honestly sir. This really isn't weird at all. Just three men having a bit of fun. It's English humour, don't you know!'

'Ping', the lift arrived at the ground floor, the guest turned around from facing Helga and stepped forward and out of the lift in one brisk move. He did not look back. He did not hurry. He just kept walking and, I guess, wondering, 'was it just a bad dream?'

No, it wasn't a bad dream. The barman behind the mahogany bar, polishing the glasses with a crisp cotton cloth, could bear witness to that. As sure as the sea rolls in over the sand of Cannes twice a day, here was a smartly dressed inflatable doll seated on one of his chrome legged stools,

The guest froze, then rubbed his eyes. It was all a bad dream?

having a drink at his bar with five well-dressed men. The atmosphere was convivial. Very relaxed. It was, as we told him, our last night.

The fattest of them was, he knew, Monsieur Pierre, Chairman of a large company from Brussels; the next fattest was Claude, his assistant, and then the others were an underwater photographer, Brian from London, his assistant Geoff and the English Creative Director, Aubrey, from an advertising agency in Brussels.

"So what have you been making photographs of?" asked the barman.

"The models we brought with us from England, we have been making photographs of them on the beach and also in the cafés," explained Monsieur Pierre, practicing his English and also being polite to us, the English. And I think, at the same time, showing off to the barman, that he could speak good English.

"On the beach, you have been making the photographs. Not in the beach, then?"

"Yes, on the beach. How do you mean in the beach?" I asked.

"In the beach. In the water that comes onto the beach. For the making of the photographs with the Monsieur Brian. He is an underneath the water photographer? He goes under the water, for the making of the photographs, does he not?"

"Usually. But not here he doesn't." I replied

"But I am not understanding."

"I do all sorts of things for my clients," explained Brian.

The barman was puzzled. He looked at Helga. He wanted to ask. He didn't. He just polished more glasses, served the drinks and thought, 'Bizarre.' Which of course it was.

And that, other than a quiet dinner in the hotel Grill, (without Helga, who I had stuffed, squeaking and creaking into the cupboard in my room) was really the end of the Cannes trip.

The next morning Monsieurs Pierre and Claude took an Air France flight back to Brussels. Geoff took all the models to the airport in the bus and returned to pick up Brian and me, and then we set off for Brussels. Geoff driving and Brian and I in the next row of seats. Helga sat up front; she wasn't over dressed for the trip, she was minus her dinner shirt and bowtie but still had a modicum of decency as she wore the dress suit trousers and a jacket, but no top.

We drew some attention on the journey as our bus whisked past other cars and through villages and towns. Helga up front, staring blankly ahead, and that mouth wide open. Was that a woman in the front of that bus? And was she screaming? Too late to look again folks, we had already zipped by.

When we got to the border, Belgian Customs checked our passports and papers and checked Helga out too, but only with the merest of glances. Too embarrassed to look closely, perhaps? Or just too tired? However, they did smile as they passed the front passenger window. Three lonely men, one inflatable woman? Well, today anything goes. C'est la vie. Is it not?

I never knew why I had to travel back in the bus. I guess it was to help Brian and Geoff navigate their way and help them with the little French I had on offer. It's only now, I've had the sneaky thought that, saving on my single flight from Cannes to Brussels and Brian's and Geoff's tickets too, may have helped fill the brown envelope with the cash that Monsieur Pierre required. I was perversely proud of what I had achieved, and Jacques was nonplussed when I triumphantly gave him back the envelope, fat and surprisingly intact.

Monsieur Pierre never got the contents of the envelope.

But he did get something else instead.

"Hello Aubrey, I need your help." There was a pause, it was Monsieur Pierre on the phone, "Urgently, please."

"Yes, Monsieur Pierre, how can I help?" I said it calmly but, I remember, I had a nasty premonition of what was coming next.

"The girl, she is here. Here in Brussels. She has the photographs. My address. Everything. What shall I do? She says she wants money. Please. Please help."

"You mean Miss Firm Breasts is here?" I feigned surprise.

"Yes. I mean no. The two girls are here. The photographs. They have them. They want to meet. They want to meet Claude and me. They want money."

"Well, Monsieur Pierre, I told you and Claude not to give them your name, or business details. And I told Claude to destroy the photographs. And you didn't do what I suggested. I can't see a way out. I'm afraid I can't help."

And I couldn't help. What could I do? Maybe Brian could help? After all, he had been willing to pay a lot for the girls, that night, back in Cannes. Maybe this time he would pay too?

"Please!"

"I'm sorry. I'm afraid you're on your own. But perhaps, Brian could help?"

Did I feel remorse? Absolutely. Pity? Yes and, well, no. His greed and lack of morals had brought justice upon him.

And now, when I look back, what do I feel? Well, as Mark Twain said, 'Of all the mammals in the world, man is the only one that blushes, or needs to.'

Monsieur Pierre retired at the end of that year.

Mark Twain would have approved of Monsieur Pierre's behaviour?

KIDNAPPED IN CANNES

Chapter Nine

We were back in the South of France, this time in Cannes, shooting a TV commercial for an American food company. And this time we were in a Cannes far more opulent than ever, for after the shoot we were staying on for the 'chic meet the chic, met the chic' Cannes Advertising Festival.

There was the usual wealth of golden-bronzed bodies dripping with suntan lotion on the beach, but now they were joined with a buzz in the streets, avenues and boulevards, by the affluent of the advertising industry. Wallets swollen with gold company credit cards being nonchalantly flashed around from meal to meal, drink to drink, club to club and in some cases, from expensive boutique to boutique.

'We' were a small TV crew from Holland travelling in a Dodge Minivan (but as it was American it was far from 'mini' – more like a motorised home that had not 'grown up' yet). It was a regular Doctor Who's Tardis. Slide open the gargantuan side door and you were greeted with a cavernous and unexpected interior. Three rows of seats, each covered in some sort of ugly crushed baby-blue velvet. The last two rows could be split into two very comfortable arm chairs with a pop-up table in the middle, ideal for a small snack, a business meeting, or a chance to do some last minute 'alts' to the script. There was a small fridge in one corner stocked with every drink (in miniature) imaginable and a selection of cold beers, some good French wine, and a couple of demi-botttles of 'bubbly'. There was also a stereo system that would put the boom-bashers of today to shame.

Silently leading the way, was our shiny, new black four-door Mercedes saloon. Freshly hired from Hertz, complete with beige leather seats and interior. The smell of the leather was an aromatherapist's delight. As we hushed our way along the Promenade de la Croisette, the

Our Tardis was a Dodge minivan.

reflections of the puffy white clouds delicately washed their way over the bonnet's deep black paintwork.

This was luxury. Or was it?

A utilitarian Ford van – the camera and gear van – completed our small fleet.

Driving the Mercedes was our gangly, young 'gofer', Willem, who despite the ferocious afternoon heat, drove with one arm nonchalantly dangling out the window. All of Cannes' hot air wafted into the cockpit, gently cooking us.

"Shut that window," the producer, Dirk, instructed the gangly youth.

Dirk was the epitome of producers of that time. His big mop of Dutch-blond hair, sat atop a face and body well-rounded with too many production lunches and wrap-party dinners. Too much rich food, fine wines and cognac. He always had a Churchilian of a cigar between his large fat lips. Sometimes lit, sometimes not. His outfits were always black. And to complete the look, Dirk, always ahead of his time, wore his sunglasses on his head. Indoors, outdoors, at the dinner table, breakfast table: all the time. But never did they appear on his actual face – I think he forgot he even had them!

Jack, the director, sat in the back with me. One of the most of respected and wealthiest of the London directors. His face said he had seen it all before: ruddy red, it had seen some great days…and nights. So tall was he, and so well worn was his face, that you would be forgiven for thinking he was a prize-fighter, or at least a bouncer. Nothing was new to this veteran of the film and commercials world. He slumped back into the soft leather; slowly closed his eyes, sighed deeply, and either snoozed, or just feigned a snooze and shut out the cliché glitter and glamour of Cannes. Been there, done that, got the t-shirt and thrown it away, years ago.

The car slowed to a crawl.

'Whirrrrrrrrrr....' The driver's electric window came down again. Willem gave out a gentle, "wow, look at that!" Followed by a breathy wolf whistle, "just look at the chicks. Everywhere! Look at that."

Jack's eyes crept open a tad. He sighed and...

"Shut that window!" instructed Dirk.

...Jack closed his eyes again.

The window whirred and closed again, with a satisfying stifled and well-engineered Mercedes Benz thud.

The air-con kicked in and bathed us in the much-needed 'fresh' air. Peace. Cool. We were cocooned and sealed from the outside heat.

The Ferraris, Porsches, De Tomasos, Maseratis, and the other glitz cars formed a continuous pageant along the promenade. Drivers blipped their accelerators to catch the attention of the sun-bronzed 'chicks'. There was the occasional throaty roar as one would speed off, until it slowed again to walking pace to try to impress an unsuspecting length of legs, then with another blip of the accelerator, accompanied by the bark of the exhaust pipe, it would speed off again to court, taunt and tease another set of legs. Sometimes the gruff growl would be embellished by a playful 'toot, toot' of a custom installed-horn.

This constant serenading didn't seem to impress anyone, but had the parade of cars not been there it wouldn't have been Cannes. Just like a cocktail in the Costa del Sol wouldn't really be a cocktail, without one of those silly little pink paper umbrellas. Remember the ones? The ones that poked you in the eye when you took a sip.

The window whirred open again.

"This is just fantastic," said Willem. "You can't help stopping and admiring, can you?" he smirked.

"Young man," said Jack very politely, "shut that fucking window and keep it closed, or I'll rip your dumb neck off."

"Just get us to the hotel, pronto," added Dirk, somewhat more politely than Jack.

The next morning, we all gathered at reception, complete with thermos' of hot coffee to give us an early morning 'jolt' as we made our way to the first location. Willem drove – windows shut – as we all stretched and shook ourselves awake.

I did think Willem was unusually quiet, well behaved and just a little unkempt that morning.

As we gathered round the catering table, well laden with fresh juices, more hot coffee, hot chocolate, fresh croissant, preserves topped with chunks of fruit, a colourful collection of fresh fruit and grapes, and cheeses that could have walked off the cheeseboard, Jack took Dirk aside.

I didn't hear all that was said, just the tale-end of something like…

"…behaving like a dog at a fair." And, "better buck his ideas up."

It was a little later that I learnt that Jack had put in a complaint about Willem. To exacerbate the situation Jack had learnt that, after we had settled in for the night, Willem had taken the Mercedes out for a jaunt. He visited some clubs, ogled some girls and tried out his pick-up lines – without success, I believe. Too gauche, no style and more importantly, no money to flash around.

As a *gofer (also known as the Unit Runner) Willem, although at the bottom of the food chain, was an invaluable member of the film crew.

*

Footnote: A gofer is also described as someone who is learning how to do tasks and fetch and carry items.

His job description meant he was there to 'go for' anything that was required. Absolutely anything. From an extra roll of gaffer tape, a replacement camera, a much needed lens, a special lighting rig, spare reflector boards, to the most mundane: fetch a cup of tea or coffee for a crew member or the client, a packet of cigars for Dirk, a few bottles of water, or a hat for the client, if he forgot to pack his, or if he left it in the hotel.

As such, he should be available, on set (unless he had gone to fetch something) all the time. And, within reason, available off-set, night or day, ready and waiting to fetch and carry whatever, whenever. For, in film production, time costs money. Lots of it. Crews are hired by the day and overtime is expensive. A small stoppage in filming can cost a production dearly.

Gofers are usually highly ambitious, enthusiastic and unerringly reliable. Their goal is to work their way up from the bottom, getting to grips with the full gambit of film production along the way. Hopefully impressing those above them, and rise to become an assistant producer perhaps, or a producer. Sometimes a director, even.

Willem wasn't going to make it. In fact it was obvious he wasn't going to make it anywhere. But we were stuck with him.

Whenever we turned to summon him he was either staring aimlessly into space. Or out to sea, dreaming about being on board one of the white-hulled yachts slipping its way through the stunningly blue, blue sea, with attendant 'lovelies', downing chilled oysters and champagne. Or vacantly attacking his fingernails, trying to extract a final piece of dirt from underneath them, with a small piece of folded paper probably torn off the call-sheet, or worse still, from the script.

Other times he wasn't even on set.

"Where's Willem? Where is that boy?" came the exhausted and, oh so repetitive cry, from Dirk.

Even when he was sent on a 'run' supposedly 'gof-fering', he usually took ages to come back. Probably taking the best, and slowest, most picturesque route back through town, in order to spend time ogling bikini-clad 'chicks', or others sitting cross-legged, skirts riding high, at the numerous cafes and bars. No doubt, the two front windows of the Mercedes were wound down and one or two 'lifts' were proffered.

It was, to put it mildly, useless to rely on Willem.

It was the second day of the shoot, around 8am. We all met at the catering table, next to the partially full but being filled, swimming pool. Cold, fresh water was gushing and gurgling into the immaculately cleaned pool, from the garden hose of the smart Cannes home. The immaculate garden was complete with tall conifers, smart green lawns and flower beds awash with a riot of colours, from miniature azaleas, deep-scented and flowering lavenders, large, happy-faced geraniums and a majestic purple Bougainvillea.

Not much fruit juice was consumed that morning. It was more a hot chocolate, or coffee-only morning. The air was sharper than normal, with a bite that forced us to don an extra layer of clothes for the first part of the day and wait for the sun to burn off the unwelcome clouds and bring us some welcome warmth at about midday.

Anyway, that was the plan.

We needed sun at midday. And we need water in the pool.

We needed a shot of a girl, with arms outstretched, slipping elegantly down a water-slide into the pool. A simple shot, but one that took careful planning.

And one that could end up being very costly if we got it wrong. We were shooting the shot at high speed, 'chewing' expensive film as it whizzed through the camera at four times the normal speed of 24 frames per second.

Over the next hour the water-slide was set-up. An 'extra' was asked to climb the steps to the top of the slide and sit on the very brink of it.

Next the camera was set up. Jack spoke to Dirk.

"OK Willem, come here please."

"Yes," said Willem, eager to please after the last telling off by Dirk.

"Go to the top of the slide and take the position of the girl."

Willem mounted the steps and took the position at the top.

"Good for you?" asked Jack of the camera operator (another professional from London, called Ray), enquiring if the lens and angle of the shot gave the best aesthetic.

"Good for me," replied Ray, "at least, OK for number one position".

"Young man," barked Jack, "we need to look at number two position. Come down the slide and into the pool, when I say action".

"Pardon?"

"I said, 'when I say action, come down the slide and into the pool'."

"Into the water?" asked Willem.

"Where else do you think? Onto the side of the frigging pool?"

"The water then?"

"Yes, into the water, young man!"

Willem was going into that ice cold pool thirty four times...

"Right, into the water?" repeated Willem.

"Yes."

"But I have no swimming gear!"

"Get your strides off and into the pool. Now, when I say action…"

"Can I go and buy some swimming gear, some trunks?"

"No time for that. Can't wait for you to frig about travelling all over Cannes looking for trunks. Time is money. This shot needs to be set-up properly for midday."

So Willem slowly discarded his clothes, down to his underpants.

"Come, come on, haven't got all day."

"It's cold."

Be colder when he hits the water, I thought. So did Jack, Willem and all the crew.

"Get on with it. Ready, Ray?"

"Good for me," said Ray.

"And…action," shouted Jack.

Willem accelerated down the slide in a most ungainly way, with overt reluctance, hitting the water almost sideways, he immediately scrambled out, dripping wet, shaking himself like a dog, chilly with cold.

"Stop playing the fool. Put your heart into it boy. Again!"

"Action!"

So up to the top of the ladder went Willem and down he came. More

controlled. Smoother.

"Number two position OK for you?" asked Jack of Ray.

"Not really. I would like to try another lens and position" replied Ray, mischievously.

And so the lens was changed. Different camera angles tried, and positions too. And with each change, the lesson that a gofer is right at the bottom of the ladder was taught. Only in this case, Willem was being taught by sliding down from very the top of the ladder. Again. And again. And again.

With various instructions:

"Look elegant. Keep your arms outstretched, young man."

"Hit the water, arms high in the air. Don't hunch-up!"

"Your arms are fine at the top. I said when you hit the water, keep your arms high up and don't hunch-up. We need to see how wide the shot is in the number two position."

Too chilly to protest, and looking like a shivering, plucked and undernourished turkey, Jack took Willem to one side and explained.

"Look. This has to be right. We don't want our actress going into that cold water too many times. Her nipples are going to stand out and we don't want that on television, do we? We have to warm her up in-between takes. We have to blow dry her hair each time. It all takes time. Time is money. If you get it right for us, you get it right for her. And the sooner you get it right, the sooner it will be over."

"Just one more time, young man."

I counted 34 attempts at getting it right. 34 'rehearsals'.

Travelling back from the location Willem was very quiet and very tired. Far from his boisterous self, he stared ahead and ignored the previously magnetic glitz, glamour and girls bobbing and bouncing just outside his view.

"These kidnappings are a bit worrying," said Jack.

There was a burden to belonging to the wealthy 'set' in the Italian and French Riviera - the threat of kidnapping by gangs, the mafia and terrorist groups such as the notorious Red Brigade, who had kidnapped and murdered the Italian Prime Minister, Aldo Moro, in 1978.

Many families moved from the constant and very real threat faced in the Riviera to Manhattan, New York, whilst others, with small children always vulnerable to hijacks and kidnapping, sent their children away to boarding schools overseas.

The trend from the late '70s spread over into the late '80s and the news around the world was awash with it. If you were rich, lived in, or even visited the Riviera, watch out for yourself. Better still, get a bodyguard!

"If they – you know, the gangs – if they knew you were here, Jack," said Dirk, "I think you'd be a target."

"I wouldn't fetch much, mate," replied Jack. "No one loves me no more these days". He said in a fake Essex accent mimicking some of the trendy 'in' directors of the day.

"No longer flavour of the month are you, mate?" prodded Dirk in a very poor Essex accent, heavily distorted by his Dutch one.

There was a time when Jack was so busy in London you couldn't get a piece of him but now he was in his mid to late 50s he was, 'so last week!'

Nevertheless he was very astute and very, very wealthy. He sold his own film production company and with only some of the proceeds, bought a farm in the South West of England, where he quickly became the local Lord of the Manor. He also, as I recall, had a gorgeous home in London, a 'Roller' and a fine Purdey, or was it a Holland & Holland? Probably a pair of each.

Nowadays he picked his film shoots and we were lucky enough to get him to accept ours. But with him came a touch of skepticism, he did not suffer fools gladly, as Willem was now a shivering witness to, and he liked a bit of fun.

"Why don't you get into the van, young man," suggested Jack to Willem.

The traffic was thick and unforgiving, driving bumper to bumper in a Cannes rush hour. Willem pulled the Mercedes over at the first opportunity and slid out of the driver's seat, disappearing into the cavernous sliding door of the Dodge Minivan.

"Ok you drive," suggested Jack to Dirk, "and I'll come up front and join you".

"It's not just the rich and wealthy of the Riviera that are a target for kidnapping," said Dirk as he nodded towards a group of armed gendarmes at the traffic lights.

"It's the rich and the wealthy in the ad and film business that have swelled the number of targets in Cannes. The gangs and terrorists have a lot to pick from," continued Dirk.

"Not all people in the ad and film business have money though. It just looks like they do", added Jack, "great titles, great clothes, ostentatious parties…" Removing his unlit cigar from his mouth, "part of the Martini set, like you," Dirk retorted, poking his cigar at Jack before plopping it back into

his mouth, with a flash of humour. "And, you don't have to look like you have money, to have money."

I knew exactly what Dirk was getting at. Jack didn't have to dress up to impress. And he didn't. His wealth was his work and his farm, his antique collection and his home in London. All proof of the man's talent.

"I agree," I said, joining in the banter, "you are absolute testimony to that Jack." (I was thinking in particular of the day before, when he wore an old pair of denims and ankle-length lace-up brown boots – that he probably wore on the farm – a battered un-dyed cotton jacket and crisp white crew-necked t-shirt to dinner. Much to Dirk's embarrassment we were ushered to a corner table in the restaurant.)

Turning his head to the back of the car, where I was sitting, Jack grinned, "Yeah, with the right props Aubs, even you could look like you had money." Then, swinging his head back round to face Dirk, with a very wicked smile, he went on, "with the right props old Aubs back there," he jerked his head in my direction again, "even he could look like he was being kidnapped."

"And Dirk, the head honcho of the Mafioso, with that cigar and dark glasses", I jested.

"Dark glasses actually over his eyes, for the first time…," Jack went on, "very mean and menacing looking".

"And what about you, the bruiser, the minder?" challenged Dirk, with just a barb of sarcasm.

"What a laugh," I said.

"Exactly," said Jack. "what a laugh. And that's what we all need."

"A laugh?" said Dirk, not sure if Jack was joking or not.

"Yeah, a laugh."

"Come on, Aubs," Jack reached into the glove box of the Mercedes, took out a roll of gaffer tape and before anyone could protest or debate the prank, he ripped some off, reached over to me and said, "stick this over your mouth. Put your hands behind your back. Look kidnapped."

So I did.

I did my best impression of a kidnapped victim. I removed my spectacles for added effect, so I could make my eyes bulge and pop in the sheer terror I was supposedly going through. Bound, gagged and helplessly kidnapped in Cannes.

As we drew alongside a car I would turn my head toward the occupants and jerk it backwards and then nod to the side, and downwards trying to draw their attention to my perilous predicament – and my supposedly heavily bonded wrists.

My wrists were, or supposedly so... bound.

Jack and Dirk just starred ahead pretending that nothing unusual was going on. Mostly. Every now and then Jack, for added effect, would whip his head round and point a threatening finger at me.

Some of the passengers of the passing cars seemed to ignore me. Either my impression was weak, or they were just British and did not want to get involved.

But for the most part the act had a good effect. A young boy, sitting bored in the back seat of a Peugeot travelling next to as us on the clogged dual carriageway, did a double take. I shook my head hard from left to right and gave my best impression of a fish wriggling and waggling on a hook. The boy peered closer and then, pressed his snub nose against the window. He turned towards what I presumed was his father, seated in the front of the Peugeot, and shouted. He shouted again and reached forward to tap his father on the shoulder, just as our Mercedes edged forward in the traffic, two or three car lengths ahead of the Peugeot and out of sight. Then, as our lane lost its superior momentum levelling us with the Peugeot again, the excited boy shouted again, the father turned and took a long scrutinising look across at me. Then very smartly turned back to the boy, and gave him a quick clip across his ear. The trouble was I had removed the gaffer tape and was acting normal – well as normal as I could manage!

After a series of particularly impressive performances, over about 50 meters of traffic-congested dual carriageway, an upward sloping slip-road beckoned – in my opinion, just in time. We had succeeded in causing suspicious alarm and outrage for a number of the passengers inching past us and although it was practically impossible for a car to stop, open its doors and run for help or to report the 'kidnap', I thought the prank had gone on long enough. I certainly didn't want to suffer the ignominy of arrest.

The father gave the boy a smart clip across the ear.

Dirk gently spun the wheel and we made a gracious, yet smart exit from the cluttered main road.

I was relieved.

Relieved to be free of the burden of being a quasi-kidnap victim.

Relieved, physically, of no longer only breathing through my nose as my mouth was taped, while simultaneously jerking, bouncing and bobbing and nodding my head up and down in the rear seat.

It was exhausting. Physically and mentally.

But most of all I was relieved that the gendarmes, hiding behind a bush or palm trunk, hadn't smartly stepped out in front of the car, pulled us over and arrested Jack and Dirk for kidnapping me. Or indeed all of us for such a thoughtless and juvenile prank. Which, of course, it was.

Yes, I was relieved, until we got to the top of the hill. And stopped the at the 'T' junction.

Out-stepped a gendarme from behind a tree. Then another. And another.

Two stood guard at the front of the car, blocking any exit from the 'T' junction, right and left.

The other gendarme stepped round to my side of the car and tapped on the window and then gestured with a circular motion of his white leather gloved hand that I should wind the window down.

I wound my window down.

"Tout va bien?" (All is good?), enquired the gendarme.

"Oui. Je suis Anglais."

"You are English?"

"Oui. Anglais. Je suis Monsieur Aubrey Malden. Directeur Creatif d'une agence de publicite."

He winced. "Please, in English."

"Yes, I am English. My name is Aubrey Malden and I am a Creative Director from an advertising agency."

"You are OK? C'est bien? All is OK?" he enquired again.

Gendarmes are scary. They don't look like the friendly British Bobbies of the day. And worse still, they carry firearms with them. Holstered pistols. Somehow you think, if they have them, they will use them. And being French, they are very emotional and I don't want an emotional Frenchman waving a pistol around me.

"Yes. I am good."

"We have had reports of a person in the back of a car, like this one here, in trouble. Are you in trouble, sir?

"No. No I'm not." I replied nervously. Aware of the pistol and of our prank. I added, for reinforcement and reassurance, "No fine. OK. Yes, OK. All is OK."

He did not seem reassured by my reassurance.

"Can I look in the back of the car?" He gestured to the boot.

Dirk, who by now has turned off the engine at the request of one of the gendarme guards, gave 'my' gendarme the key to the boot.

"Please exit la car," he said to me as he wandered around to the boot.

He turned the key and pushed the chromed button of the boot and it

obligingly sprung open.

"You have not been captivated?" he quietly said to me as he poked about in the back.

"No. No, I am OK," trying not to smile at his, 'captivated'.

The big boot was empty except for our jackets and a file of Dirk's containing the script and some French police clearance papers allowing us to shoot a scene in a small Cannes road. There was also my briefcase containing the storyboard, some papers and my passport. The gendarme had a cursory look at most items, focused on the clearance certificate and then had a quick glance at my passport. Then at my face. Then at the passport again. The picture and my face, unusually for a passport, matched perfectly. It was a new passport with a new passport picture.

There was no rope in the boot. There never had been: not in the boot or the car, and the gaffer tape was safely stuffed in the glove box. I had pulled the tape from my mouth and slipped it into my pocket as we ascended the slip road believing the adventure was now over.

Which it had been, until now. Part two was unfolding.

The gendarme had the clearance certificate in his hand.

"You have been shooting a spot TV?"

"Yes," I continued, "the driver is our producer from Holland…"

"La large black one?" He interrupted.

"Yes and the other man, he is the director. An English director." I added.

"Another Engleeeshman?" He spat out the word, like he had just bitten into something foul.

Anyone who knows the French, who is 'Engleeesh', at least, will

know that ever since 1066 the French have not been too fond of the 'Engleeesh'. Not even during the last world war when the French and English were actually on the same side. But then the SOE refused to let De Gaulle know the details of our resistance cells in his country or of the allies' invasion plans of his country, until the very last moment, for fear of 'leakage'.

Or most recently the Brits squabble with the French over almost any issue, large or small, from the provenance and naming of Cheddar cheese, Camembert, Cornish Pasties to Champagne. In my view the EU is bloated and dysfunctional and is propped up by the English taxpayer who wants to make a sharp exit.

No, they don't trust the 'Engleesh'. At all. So...

"Passport!" he demanded, as he poked his head into the open window where Jack and Dirk were. At the same moment one of the other gendarmes fiddled unhealthily with his holster.

Both Jack and Dirk handed over their passports, quite calmly, I thought. Again the studied look at the passport. Then the face. The passport, then the face, the passport and then the face...I call this 'The Wimbledon Look'. Back and forth, from face to passport. Dirk was asked to remove his sunglasses. Face to passport. Jack was studied with somewhat longer looks. Face to passport. Face to passport.

Eventually the gendarme took the passports and clearance certificate and strolled to the front of the car. He looked at the number plate, then back at the passports, then spoke to his two colleagues.

"Hollandias et deux Anglais," I heard him say.

Then, "L'Anglais qui est assis la derriere,son françois est horrible. Mais tu t'attendais a quoi? Hein, tu t'attendais a quoi?" (Translated, more or

196. *Kidnapped In Cannes*

less to: 'The Englishman who is sitting at the back there, his French is shocking! But what do you expect? Ha, what do you expect?')

They all had a little chuckle at that and added a few French 'paffs' for good measure.

Taking the passports and certificate 'my' gendarme, who I now understood to be the 'chief' picked the microphone up off the radio mounted on the back of his police bike. We heard the radio crackle and whistle into action.

He spoke into the microphone and as he did so took a couple of furtive glances in our direction. He read from the passports and then from the certificate. He put down the microphone, presumably now waiting for an order. We all waited. In silence.

By now I had stepped back into the car and although all the windows were open and a gentle Mediterranean evening breeze was blowing though the car, it was getting a little sticky – in more ways than one.

The gendarmes stood still waiting for the radio to whistle and crackle orders back at them.

We remained glued to our seats. Staring ahead.

"Just look cool," Jack squeezed out of closed lips.

We stared ahead some more. I leaned forwards a little, to stop my now dampened shirt sticking to the leather seat.

I stroked my moustache for comfort.

"Cool, cool," advised Jack again.

The radio crackled back into action. And the chief and his minions gathered round the small black foghorn speaker.

He said a few words back into the microphone, something like, 'Roger that', or '10-4', in French, of course, and then replaced the microphone. Bending my head and ear towards the open window I could just make out what was being said.

"C'est ne sont pas des Italiens. C'est ne sont pas des Mafioso?"

"Non."

"Bon."

"Ou des Allemandes? Des Brigades Rouge?"

"Non."

"Bon."

That sounded promising I thought. Good.

We were neither Italian, nor Mafioso. Nor German, nor Red Brigade.

For once, being 'Engleeesh' in France was a good thing. A very good thing.

The chief walked toward the car, handed back the car keys to Dirk, passports and certificate, and without another word waved us on our way.

"Good fun," said Jack, deadpan.

"You have not been captivated?" enquired the gendarme.

LITTLE HITLER

Chapter Ten

"You are late," said the tall Aryan who met us at the entrance to the hotel somewhere in rural Germany. "You have five minutes to go to your room, unpack and get down here again. Then we leave on ze bus." He tapped his watch furiously. "You have five minutes, zat is all!"

We, Robyn, the Account Director, and I, had traveled from Brussels to present the next three years of advertising proposals to the assembled throng of European Managing Directors of the large American farm machinery company. The trip from Brussels had taken us through rain-splattered Belgium, to the flat lands of rain soaked Holland and onto the autobahns of Germany, where no speed limit meant a few buttock-clenching moments as we sped towards our destination, desperately trying to make up for the time we had lost being stuck behind those juggernauts that block every road, and your every move, on any road within the EEC (Germany excluded, of course). The trip had taken us just over our estimated five hours. And we were just a little late.

Helmut was the local Managing Director of a large American company that made the world's leading brand of farm machinery. I stared at what stood before me. I had only seen these types of men in films. Films of the 1970s or '80s, starring a young and clean shaven Clint Eastwood, or a pompous Richard Burton as some heroic SOE officer about to shin up an 'Eagle's Nest' or blow-up a cave in Norway that housed an evil German rocket scientist and his silo of smoking rockets. And guarding the control room? There always was one, wasn't there? There would be a blond-haired, blue-eyed Waffen-SS Officer, usually played by a Max Von 'Somebody' and here he was, the splitting image, standing before me: Helmut. Square jaw, clean-shaven, short blond hair straight back, bright blue eyes, standing about six foot six. He could have been fresh out of 'Hitler's Tour of Europe 1939-45' or a guide to 'How to be a Good Aryan'. As it was, Helmut would be our host for the next day and two

nights, and the first lesson in his guidebook was obviously punctuality.

"Come on, come on" Helmut ushered us up the stairs. We dragged our cases behind us so they 'bumpedy-bumped' and 'bumpedy-bumped' up every step.

Still in shock from his greeting, we hurried to our rooms. Each of us had a pee, turned around almost immediately and thundered down the staircase to be greeted again, at the hotel's front doors, by Helmut, who was now looking down at his watch like an athlete's coach inspects a stop watch towards the end of a race. Panting heavily from our quick turnaround we stood in line behind the queue of Managing Directors waiting to get on the bus. (Why did I feel like a Jew being loaded onto a train? Was it Helmut's clipboard perhaps?)

"Good, good, excellent," he said as we boarded the bus. He looked down at his watch as the second hand ticked off the final seconds. "Excellent 19h00 hours, precisely."

Once the bus had lurched forward there was an immediate click as the microphone was switched on, immediately followed by that sort of 'boof, boof' sound as the microphone was tested by Helmut, who was blowing into it.

I looked to the front of the bus. And there stood Helmut. Bolt upright, microphone in one hand with his other hand holding, somewhat nonchalantly, the vertical rail of the door. Rocking with ease, in time to the motion of the bus, he looked like a Panzer Kaptein standing in his tank, about to give orders to the troops.

"Tonight ve vill all enjoy ourselves as ve are all going to have a real German meal in a real German beer Keller." Helmut's voice came over the speakers loud and clear, each word carefully measured. It wasn't delivered so much as a piece of information as an instruction;

enjoyment was simply not an option.

"Ve will," he bent and looked out of the window and noted the volume of traffic, "be arriving at the Keller at…" he checked his watch, "traffic permitting, in 28 minutes. That makes our arrival, at 19h30 hours. Good, right on schedule."

The second lesson appeared to be, 'stick to the schedule.'

The Managing Directors, some of whom knew each other, were very quiet at the beginning of the journey, but the tension eased after five minutes or so, and then there was a lot of whispering and mumbling and a few tentative 'titters.' Which grew into a few chuckles and then quite strong laughter. Without saying it, everyone was having the same thoughts about Helmut and what might lie ahead.

As the murmurs developed from a light trickle into a strong stream of laughs, I almost wanted to jump up and shout out loud, 'Quiet! Quiet! Or you vill be shot!' Instead I turned to Robyn who whispered to me jokingly, "He's taking us to a bunker…it could be worse, he could be taking us for a 'shower'." Robyn was Jewish.

Eventually the bus hissed to a stop as the airbrakes engaged. We parked parallel to a long stone building. It had heavy hand-cut slates on the roof and in gothic lettering on red neon were the words: 'Bier Keller'.

One by one we filed off the bus and into a large hall, set with long tables, benches and chairs. A gentleman - the patron (or whatever you called them in German) - was a stout man, wearing a white shirt and open black waistcoat, black trousers, black shoes and a white apron tied round his portly girth, who guided us to a set of wooden steps descending into the cellar.

We 'clumped' down the steps in single file and into another large hall

similar in layout to the one upstairs. This time all the tables were set. There were single chairs and no benches. Red leather menus were on the tables, as well as heavy cutlery, starched white tablecloths and napkins arranged in one of those elaborate bird patterns which, when you try and fold it like that at home, you never can, unless of course you have taken origami classes, or have an HND in hotel and catering.

Chairs scraped the wooden floor as we pulled them from beneath the heavy tables and then scraped once more as we pulled them back in again, to sit down. The intricately folded napkins were instantly destroyed as we took the them, shook them vigorously and plonked them on our laps.

Hands reached for the menus. There was a lull. All the menus were in German.

Who could speak or read German? Some of us knew a little German. Those that did know a little tried to find the words that they knew and helpfully shared the information with the others.

But generally we scratched our heads.

I knew very little German and was fearful of ordering, 'VAT not included,' which is what an acquaintance of mine once ordered in a French restaurant, as he hadn't understood a word of French.

I turned to Robyn who was good at languages, and we peered at his menu and began picking out dishes and words that he knew.

People turned and consulted each other. Was that lamb or beef? Was it a big sausage, or a little one? Was pork in it? What was the potato soup made from? Potato? Just potato, surely not?

"Stop!" Helmut shouted above the growing din of confusion. "Stop! Stop!"

Heads turned to the centre of the long table and, as one, we looked at Helmut. He scraped his chair back, and stood up to his full imposing height, "You have all taken far too long to decide". (Was this the 'punctuality' lesson again? Yes it was!) "I vill order for you!"

He motioned for the patron to come over, white note pad and stubby pencil at the ready.

"First, ve vill all have a schnapps to start vith. And zen, ve vill all drink a bier!"

The stubby pencil paused in midair. The patron looked up, ready to take 'new orders'.

"Then," he looked across to see if the patron was ready, "Then, ve vill all have zer soup. Eisbein. Und Kaiser Wilhelm pudding."

The patron folded his hands in front of him and waited to see if there was anything else. "That vill be all, thank you," Helmut dismissed the patron.

We were all very quiet. Then the murmuring began again. What was the soup he had imposed upon us? Was any one Jewish? If so, they couldn't eat the Eisbein, could they? What was this pudding? Was there to be no salad? No vegetables?

Before any of this could be debated further or indeed answered, large trays appeared, borne on the upturned palms of four stout waiters dressed in a similar style to the patron. On these trays, as large as dustbin lids, were shooter glasses of schnapps and foaming one-litre steins of German beer. One of each was set down next to every one of us. Then, no sooner than the last of us had been served than Helmut stood and, almost clicking his heels, he raised his shooter glass, "Prost!" he said, and snapping his head back he downed the fiery contents. "Prost!" we replied returneing the toast. Some gasped. Others held the liquid in check in their cheeks

Helmut put his hand-up and commanded us all to stop!

and then, when accustomed to its ferocity, let it trickle down their throats. Others moved it from side to side in the mouth, hesitant to swallow it; they let it anaesthetise their gums before they let it sink slowly down their throats and into their empty bellies. It certainly put fire into you. So much so that some of us had tears in our eyes.

"Cheers!" said Helmut, he had risen to his feet again and took a deep gulp from the stein. "Cheers!" we said in unison, some half standing, following Helmut's example. Others, still in shock from the schnapps, remained seated, but all of us were stunned that he followed the schnapps so quickly with the beer. But we were all very grateful for the beer's nullifying and cooling effect after the schnapps.

Before we could discuss anything further, the waiters appeared again and the soup was placed quickly and efficiently in front of us all. We picked up the large bulbous bowled soupspoons, dug in and slurped it down.

I turned to Robyn as I neared the end of the last spoonful of soup. "The Eisbein. Can you eat pork, Robyn?"

"I'm not a practicing Jew and, besides, I think even if I was, I would eat it. I'm famished after that five-hour trip from Brussels and now it's eight at night. Six hours without a bite to eat, I could eat a horse."

And that's what appeared to arrive on our plates next. A horse. Or at least a hock that seemed to have come off a horse, rather than off a pig. And it was delicious, with a crackling that snapped and crackled as you popped it into your mouth and underneath the crackling, a flesh that was silky soft, and it did just melt in the mouth. The sauerkraut that accompanied it? Well, let's say it was interesting, but not to my taste.

The slightly off-dry white wine that was poured into our glasses without reference to our requirements made an ideal accompaniment. It dulled the bitterness of the sauerkraut.

"SIX HOURS WITHOUT A BITE TO EAT, I COULD EAT A HORSE."

The Kaiser Wilhelm Pudding was testimony to why the Germans didn't win the First World War. With that in your belly how could you make it out of the trenches?

The evening was rounded off with another series of 'Prosts!' from Helmut, who was now rapidly becoming more Fuehrer-like with every performance.

The bus ride back to the hotel was uneventful. We were heavily laden with food, wine, beer and schnapps. As we stumbled up the stairs to our allocated rooms (stumbling because of the weight of the food, not the alcohol), the Fuehrer reminded us: "Ve have breakfast at eight o'clock and then za meeting vill commence at nine o'clock sharp, please." The way he underlined 'vill' made me, and I guess the others too, think he was going to add, 'You vill be punished if you are late!' But he didn't say that. Instead he just said, "Good night!" as though he was happy to be rid of us.

We were all sitting at the boardroom table at five to nine the next morning. We were 'all present and correct' and in front of each one of us was the timetable, neatly laid out on one sheet of crisp white paper. 'Good guidance from Helmut,' I thought. Often these things do wander, time-wise, a bit. Here was the agenda:

AGENDA

WEDNESDAY

1	09H00-09H15	Welcome	Helmut
2	09h15-10h00	Overall strategy	The Agency
3	10h00-10h15	Questions	All
4	10h15-10h30	Coffee & comfort break	All
5	10h30-12h15	Advertising proposals	The Agency
6	12h15-12h45	Tour of the factory	Helmut
7	12h45-13h00	Comfort break	All
8	13h00-13h30	Lunch	All
9	13h30-17h30	An overview of each country's economy	All
10	17h30-17h45	Comfort break	All
11	17h45-18h00	Closing remarks	Jean Claude
12	18h00-19h00	Rest period	All
13	19h00-21h30	Casual dinner at the hotel	All

THURSDAY

1	07h30-09h00	Breakfast	All
2	09h15	Depart	All

Using a long collapsible pointing stick to draw our attention to the timings and the day's events, Helmut took us through the agenda, which was also projected on the screen. He pointed out that he would, as the local Managing Director, not only be our honoured host, but would also chair our meeting for the day. Helmut finished his introduction at 9.14am.

At 9.15am we were 'on' and Robyn took the Managing Directors though the mass of research and our thinking, step by step, which culminated in us presenting the campaign line: 'At the end of the day you will be glad you used Sperry New Holland (farming machinery)'.

I then explained the creative strategy and executional guidelines: how each piece of farm machinery would be photographed with a real Sperry New Holland farmer and family (or group of workers, and or their farm dog/s etc.) with a background of a freshly harvested field (in the case of the combine harvester) or, in the case of a Round Baler, a freshly mown field in which was periodically and uniformly placed with round bales of straw in pristine condition. The sun would be setting, emphasising the 'end-of-the-day' theme. The copy would be written from the farmer's point of view in a testimonial style. We presented individual advertisements for all of the Sperry New Holland equipment (in fact, we presented all the advertisements except one, which if we felt the presentation went well, we would present that evening).

Then came the questions.

"How would we select the farmers?"

"We would select them via a competition run throughout Europe."

"How would that work?"

"Each country would nominate a farmer, or farmers, and write-up, in no more than 100 words, why that farmer, or those farmers, should

be nominated. Points would be awarded for the farmer's loyalty to the brand Sperry New Holland, his ability to use the Sperry New Holland machinery efficiently, and so forth."

"But how could the entries be fair? Surely one country manger, who had a bigger income from a larger country and more profitable crops or land could wangle it that his best customer won? Indeed he could wangle it that his country had more winning farmers than any other country, could he not?"

"No he couldn't as all countries were only allowed to have a total of no more, or less, than six entries. Each entry would be anonymous. All entries would be in English."

"In France we have a glass of wine at the end of the harvest, in England you don't. How will you accommodate the difference?"

"We will photograph the farmer, with and without a glass of wine; we will 'run' the farmer with the glass of wine in the French magazines and the farmer without in the English, if that suits?"

"In Russia the sunsets aren't as dramatic as they are in my country Spain, and in Russia the clothes are old fashioned, so how will you accommodate that?"

"Stop! Stop!" it was Helmut. Thank goodness for the Fuehrer. He interrupted this barrage of, now, tit-for-tat questioning. He was going to direct the questioning back to the more important issues. The strategic ones. He was, or so I thought, going to say, 'Gentlemen, let us get back to the fundamentals of the campaign. Will it involve the farming community and will it create impact for our brand?' But he didn't. Instead all he said was, "Stop, stop! It is now 10.15. It is time for the coffee and the toilet".

We were most dismayed. Both presenters (Robyn and I) and those

presented to (the Managing Directors) still had questions that needed answers; still we could pick them up after the 'comfort break'.

"After the 'comfort break' we will have the advertising media and point of sale proposals." The Fuehrer interrupted my thoughts, and quickly demolished any idea of answering further legitimate questions or concerns. "There will be no more questions just the advertising media and point of sale proposals, please! Now, the coffee; it is outside here." He took two strides outside the door and pointed to a table with white cups and saucers, a steaming caldron of coffee, plain biscuits and ones with jam in the middle, milk and sugar. He took two more strides to the left and pointed down the melamine-paneled corridor, "And here are the toilets, here! Fifteen minutes, please!"

I went for a pee and was joined, to the right of the urinal I was using, by a very jolly red-faced man. He was the Managing Director from Spain and he had laughter lines spreading out from his lively brown eyes. 'Full of mischief', I thought. In fact he was the one that stirred-up the questions earlier by suggesting that Spain had better sunsets than Russia and that Russians wore old-fashioned clothes and by inference weren't as dapper as the Spanish. 'Gustaf', it said on his name badge. He sported a wonderfully wild, fluffy handlebar moustache that was entangled with his out-of-control side burns. I had guessed he obtained his red-face from a combination of laughter and the large amounts of alcohol he obviously

Gustafs moustache was wonderfully big. About actual size...

enjoyed - a fact he had adequately demonstrated the previous night by drinking copious amounts of everything that was going (he had even managed to order a bottle of red wine without the Fuehrer's 'permission', and shared it quietly with those around him, placing the bottle on the floor in between pourings, so it was out of sight).

Gustaf mounted the little step beside me and unzipped his fly, and whilst taking careful aim at the centre of the urinal, he turned his head towards me and without identifying who he was talking about whispered, "He's like the camp Komandant!"

There was a pause. He turned his head away, checked his aim was still good and continued. "We," confided Gustaf, nodding towards a couple of other managing directors in attendance at other urinals at the end of the washroom, "We, have already nicknamed him the Fuehrer." He shook the last few drops off, zipped himself up, and prepared to leave.

"So have we" I said.

The next session went like clockwork, of course We then gathered at the doors to the warehouse for the factory tour. We were smartly marched around, first the warehouse, then the spare's shop and finally the service centre. Helmut bristled with pride as he explained their efficiency and cleanliness. "You could eat your dinner off the workshop floor it is so clean," he said. "Is this where we are having dinner tonight then?" whispered Gustaf "Off the Fuehrer's floor?"

"What?" said Helmut.

"I said," replied Gustaf, not alarmed that Helmut had heard his sarcastic stage whisper, "Off the factory's floor, I said you could have dinner off the floor. Very smart. Very clean!"

Helmut snatched a clipboard from one of the white-coated engineers who was 'on guard' at one of the machines and turned the pages. "On

average, parts are flown in within twenty four hours, by Lufthansa, if we do not have them in stock. These charts track all spares and how quickly they arrive and are fitted. We waste little time." He handed it back to the white-coated engineer who tucked the clipboard under his right arm; practically speaking, he was standing to attention.

Helmut turned to his audience of managing directors, "So, any questions?" he barked.

There weren't. All of us had a close eye on the watch and it was almost 12.45, time for a 'comfort break'. Besides if anyone had asked a question we were sure we would be cut off with a, 'Stop! Stop! No questions. It is time for our comfort break. 15 minutes, then it is lunch!'

The managing directors wandered off to the ablutions. Helmut stood next to the door to the car and machinery park. He stood alone.

Curiosity got the better of me. And besides, I thought if I could strike-up a convivial conversation with Helmut he would calm down and warm to us. He would be more relaxed and the team of managing directors would enjoy the day, and our work more. "So Helmut, when did you get into farming?" I asked, as I drew alongside him.

"My father, he and my mother moved to Brazil in 1944 (aha, I thought, then he's one of the sons from the 'Boys from Brazil,' a son from one of those that got way) and we started a stud farm there. But I wanted to be close to machinery, so I studied agriculture and engineering and I was top of my class (of course, I thought, he could only ever be top) and now I am the youngest managing director in Europe." he paused and clasped his hands behind his back, drew his feet together and rocked forward and then quickly backwards. "And," he added looking to the heavens whimsically, "I think, probably the most successful managing director of them all. Our debtor days are down, productivity is up, and to keep costly stocks down our just-in-time spares supply policy works

*Everything was timed to the split second.
After all, Helmut was German.*

very efficiently. We have come a long way since I took over central command. It is all very satisfactory."

He turned, very smartly on his heels, "Come, it is time for lunch. We have it in the canteen vith the vorkers. It will save important time." He marched off, and announced to all, "You have thirty minutes for the lunch. Thank you!"

Lunch was a scrambled affair. I can't remember much about the food except that it was the same as the fare that the workers were eating: heavy and glutinous. 'Very German', I thought. The coffee was something left over from the ersatz and acorn coffee days – coffee served in the German POW camps of The Second World War. Drinking it you could understand why so many prisoners attempted escape. Of course, we couldn't go anywhere, not even to the toilet if the coffee got the better of us, unless it was within the schedule. And that coffee was definitely the type that interfered with scheduled stops.

"Und now, ve vill each present the goings-on in our various countries."

The various country heads then made 20-minute presentations on the agricultural economies of their country. The number of machines per capita, per farm worker, per horse, cow, pig, in fact any way you could compare a machine, they compared it. France had more round-balers than England because they had more hills that the bales could roll down. Russia had no round, or square balers, just farm workers and horses. In a cart ratio to baler basis, either round baler, or square baler, Russia won. It had a lot of carts. Ireland had a lot of potatoes. But Russia had more. And they had more people than potatoes.

Gustaf explained that he had more shit than others. There were, he explained more mechanical manure spreaders per capita in Spain. Perhaps because of the clay laden and scrub soil. But perhaps, he added mischievously, there was more bullshit that needed to be spread because

of the Spanish politicians. We all laughed. Except for Helmut.

Helmut was next up.

"Good afternoon, gentlemen," Helmut strutted up to the front of the room, he was carrying a long pole, he took two extra steps towards two cords that were dangling down from the ceiling and pulled one of them down, emphatically and briskly.

With a 'whirrrrrrrrrrrr' and 'rattttttttttttle', a large map of Europe appeared from a sprung roller in the ceiling. Helmut immediately began prodding the middle of it with the pointing stick.

"Ve are here," he tapped Germany with the point of the pole. "Germany is the centre of Europe." He said it in a way that was not just a statement but a boast: it was not only the geographical centre, but it was also the centre of The Universe.

"To the East," he prodded the map in time with his pronouncements, "Poland, The Czech Republic, Hungary, Yugoslavia, Bulgaria, Greece, Austria und…. Russia". He swung the pole southward. "Und here," he turned his nose up, "these little countries, Liechtenstein und Switzerland," he raised his eyes a little and smiled, "und Italy." He paused and gave Holland a prod with the pole, "vith Holland, Belgium, Spain, Portugal und France in ze west". He gave France two extra taps with the tip of the pole. 'Just to keep France in their place,' I thought.

"To the north," the pole swept upwards and across, "Denmark, Norway, Finland und Sweden". The pole swept over to the left, "Ireland und…" he drew the pole back a few inches and gave England a good poke, "… England."(One for the fatherland perhaps!).

"Ve are more mechanised than any other nation," he puffed his chest out, "20% of all farm machinery in Europe is bought by my country".

He prodded the centre of the map: Germany. He cast a smile at the Italian Managing Director, "While Italy now comes only second with 18%. Und England...?" he raised his eyebrows, smirked and gave me his smuggest of looks, then slapping the back of his calves with the pole, he said, "...und England only has 7%. Ja, 7% of all Europe's farming machinery." To underline the point he gave England an extra hard prod, a special 'thwack,' with the point of the pole, which made the map swing to and fro from the impact. Memories of what his father had wanted to do in the war, perhaps?

He then turned his attention to the second cord hanging from the ceiling and tugged it, revealing the same map as before, but this time it had some interesting additions.

There was a muffled gasp. Peppered upon the map where illustrated silhouettes of combine and forage harvesters, round and square balers, muck spreaders, planters, tractors, cows, pigs and even people. And there were many arrows pointing outward from Germany into the neighbouring countries.

'It's a war map!' I thought.

He prodded one of the cows with his pole. "Ve produce more milk than any other country," he turned the tip of the pole towards a pig, "und ve keep more pigs than most of Europe."

"I'm not surprised," said Gustaf, under his breath.

"Vhat?" said Helmut; alarmed someone had interrupted his lucid flow. "You win a prize, I said," said Gustaf.

"Ja, ve should do," he continued, "ve vin a prize, for on the food production index ve are ahead, vithin Europe, 102.9% on the European index, very efficient." He beamed, poked a silhouette of a tractor, "vith

one hundred thousand tractors," he poked the silhouettes of the people, "und only twelve households per hectare of arable land." He nodded to himself in self-appreciation, "vhat is more, 1% of the workforce economy is in agriculture in Germany vhilst in Poland, for example, it is 5%. We are, very efficient. They," he prodded Poland, "are very inefficient."

"Put another vay," he said without pausing or seemingly to draw breath, "less than 10% of the population vork in agriculture, vhilst 50% of the land is farmed. You see," he said with glee, "veeeery efficient!"

Each of the points and statistics were reinforced by projecting them, in bullet point form, on a screen to the right of the large map. He also poked the figures from time to time with his long pole.

"However, apart from our success in agriculture, at the heart of our economy is industry. Ve are a very industrialised people. Iron und steel. Ve are one of, if not the world's leading producer of vehicles, machinery and farm machinery, machine tools und electrical goods." He then tapped the arrows with the pole. "It is possible, that ve …" he drew himself up to his full height, and paused for effect, "…that ve could supply the rest of Europe, particularly here, here und here," he prodded a few of the surrounding countries, "vith all the machines they could want. Yes, from here ve could do it. Thanks to my command, und our efficiency. Gentlemen, I thank you very much."

"A master plan," said Gustaf.

"Vhat?" said Helmut.

"I said, a masterful plan," replied Gustaf.

And that was it. No one said a word as everyone left the room. Some to smoke. Some to visit the toilets. All to jolt their systems with another powerful cup of coffee from the steaming cauldron.

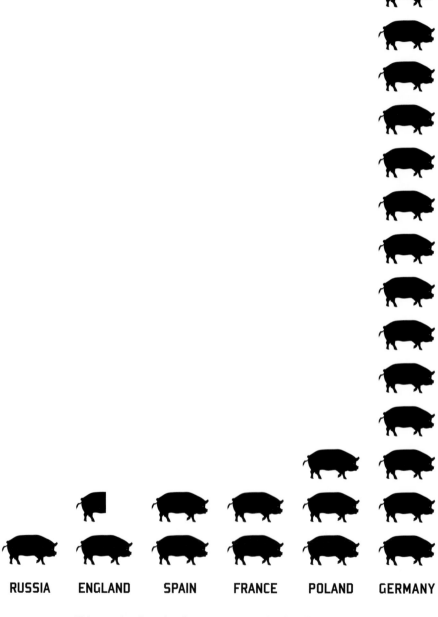

RUSSIA ENGLAND SPAIN FRANCE POLAND GERMANY

Helmut pointed out that Germany was way ahead on the swine count

As I left the room I turned to see Helmut looking transfixed by the map, moving his head gently up and down admiringly and approvingly. Was he living his dream?

"He's not serious, of course," said Jean-Claude, who was the Managing Director from Belgium. "It's just wishful thinking."

"I hope so," said Gustaf.

"Just a dream," said Jean-Claude.

"Hitler also had a dream," replied Gustaf, whilst taking a long drag on one of those thick and stinky Spanish cigarettes that crackled as the paper burnt down because of the small amount of Salt Petre in the poor quality tobacco.

The smoke break over, Gustaf purposefully stubbed the fat and now stubby cigarette out in one of those extra heavy utilitarian glass ashtrays. 'Probably made in Poland,' I thought.

Jean-Claude, who had co-coordinated the meeting, called it to order for the last time. He summarised the salient points, thanked all those present for their input and informative presentations. He thanked Helmut for his organisational skills and the in-depth presentation on the German agricultural economy. Helmut spontaneously stood up and shook Jean-Claude's hand, bowing abruptly as he did so, almost clicking his heels. Jean-Claude looked at his hand, as it had been heavily pumped by Helmut, and said what a firm grip Helmut had on the state of farming in Europe. We all got the little joke, except Helmut.

There was, explained Jean-Claude, still one more advertisement to show. When we had been preparing the advertisements, back in the agency in Brussels, one of our illustrators came to show me a 'spoof' advertisement he had mocked up as 'just as a bit of fun.' He did it for a

laugh and after he had showed it to me planned to chuck it in the bin. It amused me. It was a touch of male humour and was probably just right for the all-male audience of Managing Directors in Germany. I showed it to Robyn. He laughed.

"What do you think?" I said, "If the day goes well in Germany maybe we show it at the end of the meeting?"

"Let's take it with us then, we'll see how the day goes," Robyn agreed.

"So," Jean-Claude concluded, "I would like to thank in particular our advertising agency, for their hard work and in particular, Aubrey Malden and Robyn Sullam." A slight conspiratorial smile broke on Jean-Claude's face as he turned to Robyn and me (for he knew what was coming next). "They have, as I explained earlier, one final advertisement to share with you. I think that it is one that fits in admirably with our new advertising theme: At the end of the day you will be glad that you chose Sperry New Holland. Over to you Aubrey."

I stood up, walked to the front of the room and dramatically revealed an enlargement of the 'spoof' advertisement. There was an instant roar of laughter. Tears rolled down cheeks. Gustaf went redder than normal. Some held their bellies to hold the laughter in. It was a great release after a day punctuated with facts figures, budgets, time keeping and seriousness. Everyone was laughing. Except Helmut.

"Don't you see?" said Gustaf to Helmut. "Look here!" Gustaf beckoned for the 'spoof' advertisement to be passed down the line to him, where he was sitting next to Helmut. The advertisement was passed from person to person, and as each recipient got a closer look, there was an immediate increase of hysterical laughter.

Eventually the 'spoof' advertisement arrived in Helmut's hands.

"Don't you see?" roared Gustaf again, "there, above the headline, At the end of the day you'll be glad you chose Sperry New Holland, look at the cartoon!" It was a cartoon of a haystack. In the background the sun was going down, and sticking out of the haystack was a pair of female legs, the feet pointing skywards. And on top of the female legs? A pair of male legs, knobbly knees and hairy calves and thighs, feet pointing earthwards. A naked and hairy male bottom was just poking out of the top of the stack. For added effect, hay was being tossed into the air to add emphasis to the action that was going on in the stack.

"You see," said Gustaf, "it's a couple in the haystack. Having sex. It's funny. At the end of the day you will be glad you chose Sperry New Holland!" roared Gustaf in anticipation of Helmut getting the gag. Then there was a lull in laughter and all heads leaned in and turned towards Helmut in great expectation.

Silence from Helmut. Silence from those holding their breath in anticipation.

"It's very funny, get it?" egged on Gustaf.

A little more silence from Helmut. And then…

"Ah ja" said Helmut quizzically, "it's very funny." He said it with a deadpan face. There was an incredulous pause and the unimpressed Helmut handed the advertisement back, while the Managing Directors started putting in their orders for their own private copy of the advertisement.

That night we had a relaxing dinner. Unencumbered by Helmut's rules and regulations, the drink flowed along with the jokes, anecdotes and mimicking of the war maps being pulled down from the ceiling and prodded and poked with the pole. Food was ordered with gay abandon. Some ordered what they knew, others ordered without a clue as to what it was that they had ordered. "It's probably pig anyhow," laughed Gustaf and mimicking Helmut said, "ve have more pigs than anyone.

The cartoon that inspired the spoof advertisement.

Und bags of potatoes too, so eat up vile stocks last!"

The stiffness of the whole occasion melted away and good friends were made over that dinner. Friendships I wish I had kept going. I lost contact with Robyn after ten years and Gustaf I never saw again. I shall never forget him, for one simple thing. The next morning.

Helmut was in the hotel lobby dutifully waiting to wish everyone goodbye. A few Managing Directors shook his hand unenthusiastically, before Gustaf, waiting for his moment, marched up to Helmut, with a good majority of the Managing Directors looking on. He halted, clicked his heels, put his left fore- and index fingers under his nose signifying a moustache, and saluted with the straight-arm Hitler salute, barking out loud, in a good imitation of a Prussian officer's voice, "Mine Fuehrer, sank you very much. It's been a pleasure!"

With that, Gustaf turned and marched out through the open doors of the hotel, with the air of a recently liberated prisoner of war who was saying goodbye to the bossy camp kommandant.

SIP, WHEN THEY SUP

Chapter Eleven

The Theakston Brewery in Masham, North Yorkshire is a jewel in the crown of the brewing industry in Britain. And within the centre of that jewel was the dry and sparkling wit of one of the Theakston employees, that of Master Cooper Clive Hollis.

"So, policeman says to me, 'Clive, when I see thee again lad, I'll stop thee and take your license away'…"

Clive, now sixty-five and still making barrels entirely by hand, was regaling me with some stories about the brewery. The conversation had drifted away from the original purpose, to talk about the history of the brewery (which was as rich, and sometimes as dark, as their famous thick strong ale, Old Peculier), to talking about some of the perks of being a cooper at the brewery. As you can imagine, perks usually revolved around beer.

We sat in the Visitor's Centre surrounded by old photographs, brown bottles misshapen with age, all wobbly and unable to stand upright – they looked like they had a touch of glass-like arthritis. There were the old brewery barrels, a donkey (the original 'workmate' that held the staves they shaped to make the barrels) and the ancient coopering tools (some 200 years old and no different from the ones Clive still used). We were into our second pint and it was only 8.45 in the morning.

Clive had explained to me that he had had a motorbike some years back. An old Norton five hundred cc.

"Bike had sidecar, you see." He supped long on his pint and I sipped short on mine. He licked the creamy foam from his lips. He smiled and his cheeks pushed out, rosy with age and with many years consuming the brewery's finest on a daily, if not hourly, basis.

When he supped again, I sipped.

I had learnt the art of these interviews. When he supped, I sipped. That way I could just about pace myself. I also recorded the interviews just in case the alcohol got the better of my memory when I wanted to recall the anecdotes, such as now…

"Sidecar weren't for passengers though," Clive continued, "brewery gave you free barrel of beer in those days. So I used ta put barrel in ta sidecar and take it home, you see."

"I see."

"Well, it were usually on Friday nights when I had been ta pub. I used to get on bike, put barrel in ta sidecar and I'd be on my way…"

"You'd been drinking, then?"

"Right. But you know only three or four like (he forgot to add the other eight he might have drunk during the day). And it weren't far home besides. Bike used to know its own way home practically by itself, I think. Except one time it forgot. I had been in ta pub and had a few, but it had been snowing like hell and road was right white. You couldn't see a thing. You couldn't see road. But then, all of a sudden like, I knew bike had come off road."

"Why was that then, Clive?"

"Well, I knew it had come off road like, because it were stinging nettles kept hitting me in face!" said Clive mischievously.

"Right."

"So, anyway, back ta other story, we were in pub, with the policeman in pub too, young Bob, it were. He was there drinking with us in uniform and he strolled over ta me and he said, 'Clive, one day, when I've seen thee've been drinking here in pub, I am going to stop you on your bike

Clive would stand up, take a sup of beer,
and launch into one of his mischievous tales.

lad, and take ya license away'. So I said, 'no you're not.'"

"And…" I said.

"He said, 'I am. I am going to take license away.' So I said, 'No you're not!'"

"He said, 'I am.' I said, 'No you're not!' He said, 'I bloody am!'"

"So I said, 'you're not,' and he said, 'why not?' And I said, 'Because I haven't got fucking license to take away, have I?'"

The story was one of many anecdotes told to me that demonstrated the blunt Yorkshire folk's wit, which was also their charm. And it demonstrated the closeness of the community, for the then Constable Bob, who shared many a pint with Clive, was now just plain Bob, and worked alongside Clive in the brewery!

Many of the stories Clive and Bob told us contributed to a series of advertisements we produced for Theakston Ales and in doing so increased the beers' sales by over 29 % per annum, moving them from 45th in the market to 5th. The work received many awards including British and American Effectiveness Awards. Of course we celebrated the successes by sharing a few ales with the Theakston team. The more sensible members of our team sipping when the Theakston boys supped!

We grew the Theakston brand from 45th in the market-place to 5th. An average growth of 29% per annum.

A KNOCK AT THE DOOR

Chapter Twelwe

"Sweets, chocolates, cigarettes." A high-pitched, but 'dolce voce' voice came from outside my hotel bedroom door in Amsterdam. It was about 2am. I was exhausted. And I was now also very grumpy for, having managed to fall asleep, something I am not good at in the best of times, I had just been woken up by the repetitive call of...

"Sweets, chocolates, cigarettes." The voice was insistent, and was now accompanied by a soft, gentle knock at the door.

"Sweets, chocolates, cigarettes." I knew that voice.

"Go away, Robert. Just go away." I whispered for fear of waking the other hotel guests.

"Come on monsieur. Open-up, I have gifts for you. Sweets, chocolates, cigarettes."

"Robert, please," I raised the volume a touch, "please, just piss off. Please!"

There was a silence. Thank goodness for that. I breathed a sigh of relief. Picked my head up and buried it into the down pillow, plopping another pillow over my ear for further soundproofing. There was more silence. And then, a muffled...

"Please. I am sorry. Sweets, chocolates, cigarettes. Aubrey, I am truly sorry. Let me in!" said the voice, now mimicking a Spanish waitress, amusingly badly.

"Señor, please, see my wares. I am sorry, Señor."

"Robert just go. Just fuck off, will you!"

"How shall I fuck off, please?"

"Robert, go away, walk down the corridor. Just go away."

There was a stronger 'tap,tap,tap' on the door and a 'please.'

The high-pitched voice came from outside my bedroom, "Sweets, chocolates, cigarettes?"

SWEETS,
CHOCOLATES,
CIGARETTES.

"OK, OK, but just please be quiet." I drew the chain back and turned the lock.

I opened the door to Robert. He was a stout Dutchman. He had a short, clipped beard, which matched his slightly-bald-on-top-but-not-that-radical-yet grey hair. He was impeccably dressed in a grey business suit, button-down white shirt, simple blue tie and black penny loafers – bought in the States. Round his neck he wore a huge band which, in turn, was connected to what in Britain, many years ago, would have been the kind of tray worn by cinema usherettes to sell chocolate, ice cream and 'Kiora' cold drinks from. In Holland, where we were, the girls wore these trays from club to club selling sweets, chocolates and cigarettes and, I believe, sometimes dope.

Robert stepped into the room and apart from the tray, he was also wearing an apologetic smile.

"Sorry," he said, stepping forward to give me a big, but gentle, bear hug.

The tray got between us.

"Where did you get that?" I said, pushing the tray to one side. I shook my head in disbelief, "Did you pay for it, or steal it?"

As Robert disentangled himself from the tray, he explained that he had seen a passing girl and bought the whole 'thingy' from her, at a vastly inflated price.

"I bought it for you, to say sorry," he explained.

"OK, now that you're in, I suppose you want a drink?"

"Champagne, of course," he said, settling the tray down on my bed, "to celebrate a wonderful two days and, specifically, to thank you!"

"That's not what you said about two hours ago, Robert."

"Yes. I know. I'm truly sorry."

"Two hours or so ago, you said we had let you down. You fired the agency. You fired us, Robert."

Robert was our client. But no ordinary client. He was the client we earned the most income from. You loved him. Then you hated him, a lot. I had been through the hate bit when I stormed off to bed earlier, leaving him in the bar with our Account Director.

As I left, Robert lost his cool, and said, "In fact, I'm so fucking annoyed, I'm firing you. The agency is fired! Fired! I'm calling Albert – our Managing Director – now. Fired. OK!"

We had 45 products that we promoted for him. We produced all his advertising, all the promotions, all the sales material - for every single product. And we produced all of it in thirteen different languages. In total, we produced one thousand eight hundred pieces of artwork each year. We had three months to conceive the work and during those three months we worked nights and weekends, constantly reviewing, changing and tweaking the work with Robert, who approved it as we went along. It was a mammoth task. A whole creative group was involved and everything had to be thoroughly costed and made to work within the budget.

We were now in Amsterdam where we had presented all the work for the forty-five products, along with a detailed budget breakdown and production schedules, to the various country heads of Robert's International Corporation. They had

It was a truck load of work!

flown in from all over Europe. We had arrived from Brussels by car and truck; the truck contained all the creative work, the car, the Account Director, Production Director, Account Executive and me – the creative head responsible for all the work.

The presentation lasted two days and I had been on my feet for two thirds of the time presenting each of the various campaigns.

We were all exhausted, including Robert.

The presentation went well. Very well, except for one tiny glitch. One piece of work was left behind in Brussels. So, we were fired there and then.

"Robert, stop it now," Frank, the Account Director, urged.

"You are fired! Fired!" Robert's face turned bright red, except for the four-inch long scar that ran above his left eyebrow, up onto his forehead and disappeared into his hairline. It remained white, as it always did when Robert lost his temper (I often wondered, had someone smashed a bottle over his head in retaliation for one of his numerous rages?).

This was a very awkward time for me. I had, and so had the team, worked very hard to turn out the best work possible for Robert. He was a most demanding man. Demanding of himself and those around him. He constantly travelled the world promoting his products. We wouldn't see him for a month, and then suddenly he would drop in and demand to see what progress had been made on his work. Sometimes he would brief in a new job one night, take the complete team out for a drink (unless you were one of the lucky ones who could hide from the drinking session) and then demand to see the idea early the next morning, before he flew off to New York or Australia, or wherever. He was heart attack material. For himself and us too.

"I'm sorry Robert. Fire us then." Frank, was sailing very close to the

He was
heart attack
material.

wind. Robert's business accounted for around 25% of the agency's income. It was also the largest account that I supervised. Lose the business and we would lose people and probably my job too.

But quite frankly I had had enough of Robert that night, I knocked back the remaining champagne that Robert had so generously bought and then I had stormed off to bed. Stuff Robert. Stuff his business.

Now Robert was standing in my room with a tray of 'sweets, chocolates, cigarettes' dangling from his neck.

"I'm sorry," Robert said. "You did a great job, come down to the bar." he shrugged his shoulders, gave me a hug and said, "Just for one more drink…"

So, Robert picked up the tray and I threw on some jeans and a T-shirt and we went down to the bar. It was empty accept for Frank.

He was sitting on a barstool with a Marlboro in one hand and a tumbler of whiskey in the other. He always looked the gentleman, dressed in the best grey pin-striped suit, button down blue shirt (with the stud that ran behind the tie connecting one side of the collar with the other), spotless black brogues, a fine round faced gold Omega watch with roman numerals and black strap, and understated cufflinks.

Frank put the burning cigarette down in the ashtray, the tumbler onto the bar, and smiled. He put his arm around me and said, "Don't worry Aubrey, Robert always does this at least twice a year, fires the agency, I mean. But it only lasts for three minutes or so. The tray with the sweets, chocolates and cigarettes is his peace offering. He first did it to me in Spain, three years ago."

"Sorry. Love you," said Robert, giving me a soft, bear hug.

"Love you too. You bastard," I replied.

Working for Robert made you love him a lot and hate him. Me, on a "love day."

DEAR PRINCE CHARLES, WE WOULD LIKE TO HELP

Chapter Thirteen

One of the greatest privileges I have had in my advertising career has been the chance to work for various charities. I worked on an account for Amnesty International and Guide Dogs for the Blind. I also worked on Prince Charles' The Prince's Trust charity (www.princes-trust.org.uk). I got intense pleasure from seeing the often moribund faces of the young, and the poor, light up with broad smiles, sometimes accompanied by big tears of joy — usually mine — when the recipient was given, with no strings attached, a reasonably large amount of money to help give them a much needed leg-up in a deprived life. Sometimes it was money for a sewing machine, perhaps to start a small clothing repair shop in a back room, or even to help try answer a dream, to try to elevate the recipient into the fashion world. Other times, perhaps the dream was fuelled by a loyal supporter of The Prince's Trust, such as Phil Collins of 10cc; it would be, 'Please sir, could I have money for a guitar, or a set of drums, to start a band?'

Anyway, I had seen a documentary about Prince Charles' The Prince's Trust, The King George's Jubilee Trust and The Queen's Silver Jubilee Trust. I was captivated by what the charity was offering in those days: helping the youth of Britain, but not just any old youth, it was help for the most disadvantaged youth: those from poor backgrounds and broken homes.

I wrote a straight-from-the-heart letter simply addressed to: 'Prince Charles, The Prince's Trust, Buckingham Palace, London', offering our advertising agency's help, in whatever way an advertising agency could help. Raise awareness perhaps? Ask for helpers? I doubted that they needed funds.

The Managing Director of the agency sniggered when I had written the letter and told me, in no uncertain terms, that I was unlikely to get a reply as I had not addressed the letter in the right formal (and groveling) manner that the Prince was accustomed to, or indeed that etiquette

required. I replied that I thought the Prince might get enough groveling letters with over-elaborate addresses and salutations and that one, simply addressing him as, 'Dear Prince Charles' and straightforwardly written, might just be seen and read amongst the sack full of sycophantic mail his office and secretaries sorted through each day.

Ten days later a letter arrived from Tom Shebearre (now Sir Tom Shebearre), the first fulltime Director of The Prince's Trust, asking me when would it be convenient for me to meet with him and then with Prince Charles.

I telephoned Tom, introduced myself and made an appointment to see him. I told him I really didn't think it was necessary to meet with Prince Charles, unless Tom thought it important. I realised that Prince Charles was busier than me and I just wanted us to do a job for the Trust. I wasn't chasing a handshake from the Prince.

In our first meeting, Tom explained they had a predicament: should they remain with the three names, The Queen's Silver Jubilee Trust, The King George's Jubilee Trust and The Prince's Trust? Given the brief that the Trust was having difficulty persuading the young and impoverished to come forward for the 'free money' because they thought the 'Royals' would not really want to give 'them' the money, I suggested the names 'The Queen's Silver Jubilee Trust' and 'The King George's Jubilee Trust' be divorced from 'The Prince's Trust, and should be branded simply, 'The Prince's Trust.' It made sense to focus the brand around the Prince who, being younger than the Queen, could at least be seen, perceptually speaking, as relating a little better to the 'youth in need.' And besides, should a company have three brand names? In communication, simplicity should always rule. Even when you are dealing with The Queen.

Tom replied it was going to be a little difficult to persuade Her Royal

Highness The Queen of England to remove her trust's name from the royal venture. Of course 'a little difficult' was an understatement. He smiled when he thought of the task ahead and asked me to repeat my thinking, so he could write it down.

"It's done!" said Tom at the next meeting, adding, for dramatic input, and with tongue-in-cheek, "though she wasn't amused."

He explained that he had met with Prince Charles and that he had followed the logic of the single brand, with his name attached. Prince Charles then agreed to meet with his mother to start the process rolling. Or at least try to. I understood that very soon after Prince Charles met with his mother, Tom found himself at a London event (as I recall it was watching a theatre show with the royal family, aides, associates and friends). Tom was sitting two or three places away from The Queen and during the interval she asked the person sitting next to Tom to change places with her. The Queen was now sitting next to Tom.

"What's this I hear about removing one's name from The Prince's Trust?" she whispered to Tom.

"Well Ma'am," I think Tom must have said, "it makes sense for the following reasons - you can't have three names; that is confusing for the youngsters. Is it you or the Prince giving the money (actually at this time I think it was both) and the difficulty is the impoverished youth are having problems believing that the Royal Family will give money to the likes of them because they cannot relate to you. You are above them and they believe you cannot relate to them. At least Prince Charles is a little closer age-wise (then he was 38)."

I think Tom also explained to the Queen that by removing her name from the brand would also leave her, unencumbered by the Prince's name to do what she wanted to do with The Queen's Silver Jubilee Trust and The King George's Jubilee Trust.

"KEEP IT SIMPLE... EM YOUR MAJESTY!"

As the candles were blown
out, the Prince started dancing,
"but not like my dad,"
said one teenager.

This was back in 1985 when Jim Gardener was appointed as Chairman of the Trustees and Tom Shebearre was the Trusts' first fulltime Director. Now as I write this Sir Tom is the Director of The Prince's Charities and I wrote to confirm the above story and was somewhat taken aback when I asked Sir Tom to clarify my recollection about The Queen edging alongside him at the evening event and sitting next to him and "not being amused" at the name change suggestion. Sir Tom replied in his email, "it never happened." Hmm, I wonder why?

Anyway, after it the name change was agreed, designs went ahead for the new Prince's Trust logo and a small advertising campaign was conceived, targeted at the impoverished youth, to make them aware that funds were available, and to persuade them to 'put up their hands' for some lolly to help them improve their lot in life. The campaign we were putting together used very earthy black and white pictures of the youth. The very same youths that had already received money from the Trust.

I remember one highly distinctive kid. He had the wiry build of a flyweight boxer (and a demeanor and language to match). His upper torso, neck and arms were completely covered in very closely-packed, continuous tattoos, deftly executed in fine blue ink. As far as I remember it was of a magnificent muscular dragon that wrapped itself around the youth's sinewy body, only to be met and haltingly challenged on the kid's back by Saint George, astride his rearing snorting steed. St. George was about to plunge his trident into the dragon's fire-breathing mouth. Its artistic merit was magnificent and must, by comparison, have consisted of more intricate tattoo work than the entire All Black's rugby team displays today. The graphic black and white photograph of this youth with his stony-eyed and gritty stare was so engaging, so relevant to the target audience that I felt it would be the centerpiece of the campaign. That's what I thought until some middle-aged frump said, "Oh no! We simply couldn't use that photograph as 'it' (the youth) is just too ghastly

for words." "Besides" she added, as my jaw hit the floor, "we don't want to be seen to be encouraging tattoos, do we?"

In 1988, Prince Charles celebrated his 40th birthday and the party was to be as unique as the Prince. His huge birthday party was to take place in a once derelict tram shed in Birmingham, on November 14th. The shed was decorated with the national flag and red, white and blue balloons and over 1,500 young Britons, who benefited from The Prince's Trust, were there to greet him. It was an event that seemed to be the stuff that was made for pop stars.

And a certain aspiring pop star was not going to miss out on this glamour-clamor occasion. It was our own MD, the one who had sniggered and snorted when I had first written to Prince Charles offering our services. As momentum on the account increased our MD's curiosity and sense of the opportunity for self-promotion grew. In fact, our middle-aged MD was known, throughout the industry as 'The Walter Mitty of Advertising' for his daily indulgence in fantastic daydreams of personal achievements. He was a curious man to look at. A shaven-headed Scot with a pencil thin moustache. Most of the hair that had vacated his head seemed to have landed on his eyebrows. They were as thick as broom brushes and seemed to have only two positions: up or down. Up, when he saw an opportunity that pleased him, or down when he was perplexed. Which was quite often. Regardless of the weather, he always wore the lightest of summer suits – usually a silk and mohair Armani number that shimmered like a peacock's plumage when the flapping trouser leg, or open jacket caught the light. His ties were of a similar ilk. Shimmery, I mean. Colour-wise they covered the full spectrum. In one tie. He carried all his accessories: flash pens, pencils, and so forth in a leather handbag. My mother said he looked like a 'bookie's assistant.' I think he did, minus the trilby hat, of course.

His eyebrows were now in the 'up' mode for he saw an opportunity

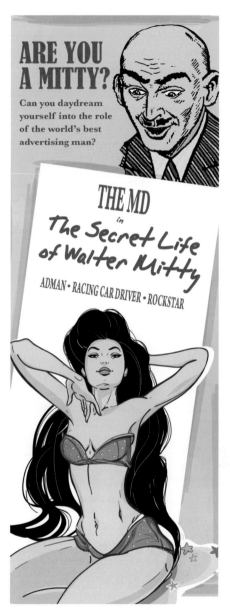

ARE YOU A MITTY?

Can you daydream yourself into the role of the world's best advertising man?

THE MD
in
The Secret Life of Walter Mitty

ADMAN • RACING CAR DRIVER • ROCKSTAR

*Our very own Walter Mitty our M.D. Adman,
Racing Car Driver & Rock Star. Not!*

to become a famous promoter of a band at Prince Charles' party. A promoter of his own band. So rubbing his hands, well-greased with the expectation of the fame to come, he volunteered that his amateur band, called something like 'Mad Dogs', would be happy to play at the party for no charge! I was more than embarrassed at the imposition. I don't know what Tom's reaction was at being handed this hot potato. But, ever the diplomat, he thanked the lead guitarist of the soon to be discovered 'Mad Dogs' for their kind and considerate offer. He would consult the organising committee. Phil Collins was due to play at the 'after party' party at Buckingham Palace.

What happened next blew the world apart. The hot potato up-graded itself to one filled with uranium.

My wife, who was the Senior Art Director at the agency, recalls that after he (the MD) wormed his way alongside The Prince's Trust and offered-up his band, some 'red-top' newspaper like The News of The World ran a lead article with a big bold headline like: 'DRUG-CRAZED POP BAND TO PLAY AT PRINCE'S FORTIETH!'

We thought it was a joke. Unfortunatly not.

The copy then went on to explain the scoop. That the band, lead by a leading advertising executive had been selected (amongst many) to play at the Prince's party where many of the impoverished of Britain would attend. It also stated that the band used drugs to get them high before they played their wild and drug-enthused music and many of the youth who were the camp-followers of the band used drugs to give them the energy to move to the extravagant sound of this really off–the-wall band. The group had not yet had a hit, but expected one shortly.

It ended, as I recall, that the band was currently rehearsing a special Mad Dogs' version of 'Happy Birthday To You', which was going to be the finale of their gig, when they would lead the assembled throng of youth and dignitaries in tribute to Prince Charles and his fortieth.

Gob-smacked I put down the newspaper almost as quickly as it been handed to me. Members of staff rushed into my office brandishing the article.

"He's done it now!" shouted one.

"Oh my God!" shouted another.

"What's The Prince's Trust going to say about this?" said another.

"We'll lose the business!" added another.

The phones were ringing in practically everybody's office. "What was our MD up to now?" and "It must be a joke", as the MD's band was no more than a muck about in the MD's front room, once in a while.

The MD called me into his office and confided in me that he hadn't a clue how this could have happened. Did I?

Yes, I had a clue, Walter Mitty. The very same man who drove his red sports car about town with the headlights (and his twin fog-lights) blazing

The phone purred loudly.
Signalling that Walt had arrived!

during the day. The very same 'Walt', who when mobile phones first hit the scene, was one of the first to buy that massive 'brick' of a phone. He carried it into a conference and instructed our Media Director to call him during the meeting. When the phone purred loudly on his lap he feigned astonishment and an abject apology as many pairs of scornful eyes zeroed in on him. Nevertheless, he boldly stood up so all could see who owned the new executive toy, and answered the call. I swear he was almost looking for applause. He certainly wore a little smirk of self-importance. Yep, wherever he went he liked to stand out, like a kilt on the Champs Elysees.

But now all eyes were on 'Walt' for a very different reason.

There then followed a series of frenetic days when the MD (every moment he seemed to become more ashen-faced) darted around the office, from chair to chair, from phone to phone, like a frightened rabbit on methamphetamine. Pulling his chain, it was either the press phoning, or it was his PA calling out to him, "I have Mr. Tom Shebearre on the phone for you" or "Jim Gardener on the phone for you, from The Prince's Trust."

He would then disappear from the meeting into the privacy of his office, closing the door firmly and then reappear some ten minutes or so later, looking like a punished schoolboy who had just had 'six of the best.' His wincing smile attempting to camouflage his obvious pain. His hands would twitch throughout the meeting that followed and, if he heard his phone ring again in his nearby office, his body would involuntarily begin a sort of St. Vitus dance routine with shoulders convulsing and neck jerking from side to side, in contrapuntal motion.

I was privy to one of the early calls. The MD usually took his calls on speakerphone. This time he didn't, but I could hazard a guess at what Tom or Jim was saying at the other end. With his eyebrows fully in their

'down' mode, he nervously shuffled the papers around on his desk and groveled down the phone.

"No, no, it wasn't me. I would never tell the press."

"Certainly, I quite understand. Most embarrassing."

"I can't understand who could have leaked it."

"I will direct all enquiries to your office then."

He then mopped his brow with a folded handkerchief from his jacket pocket, took a gulp of coffee, stuck a cigar into his mouth, flicked and fiddled with a lighter that wouldn't light, then put the cigar down in his ash tray. This was followed by another gulp of coffee, re-folding of his arms, then opening them, starting the whole twitching routine again.

He must have felt extremely silly.

The work we had produced, re-positioning The Prince's Trust was to be displayed, and I was invited. But I refused, preferring instead to give my invitation, security clearance permitting, to Caroline Graham, our young and talented Designer, who had produced a large amount of the work.

Before leaving for a celebration at the other end of the social spectrum: a lavish birthday tea, no doubt with 'one's best china', at Kensington Palace and a right royal knees-up at Buckingham Palace with entertainment from 10cc and Phil Collins, I was impressed to hear that Prince Charles danced the day away with several young women at the Birmingham Tram Shed, to the accompaniment of a West Indian steel band. "He didn't dance like my dad," added one surprised youngster, "although I danced slow and he danced fast he told me I was a 'good mover'!"

The Prince is incredibly passionate about helping people, particularly the young. He could have quite easily spent the day at Highgrove,

sipping champagne out of a crystal glass, but instead he chose to spend the time with those he really does care for, in a big draughty tram shed in Birmingham. He has a great sense of humour. Wearing a big badge 'Life Begins at Forty' he made a very funny speech (ridiculing himself) about how he talks to plants, and accepted a huge birthday cake and an enormous card signed by as many people as could get their pen and ink onto the card. I understand for his 50th birthday he got a garden gnome birthday cake and for, rumour has it, his 60th, a birthday cake in the shape of a bus pass.

PAUL McCARTNEY AND THE HOLY SPOOK

Chapter Fourteen

One of the most disappointing, yet at the outset, the most thrilling charity account I worked on was the World Wildlife Fund (WWF). Ultimately, it got me fired.

WWF was conceived on the 29th April, 1961 and David Ogilvy, my big boss at Ogilvy and Mather, was one of the founders. Although he said he had 'retired himself' in 1975, he was the self-appointed Creative Head of Ogilvy and Mather worldwide. All Creative Directors, in the one hundred and sixty-five offices, in the thirty-nine countries reported directly to him. Amongst us, David became known as, 'The Holy Spook.'

David lived 'just down the road', as it were, from the Brussels office, where I was working as the Creative Director. David was the resident 'patron' of a 12th-Century monstrous chateau: Le Chateau de Touffou, a place he bought with his substantial Madison Avenue wealth in 1966.

The Chateau, close to Bonne, is a pile of ancient apricot-coloured stone, only 150 miles south of Paris. "So close," said, one of the Directors of the Paris office, "that David can reach out of his chateau's window and grab your collar if he doesn't like what you are up to." The chateau's maze of rooms and eight centuries of additions and alterations had finally given birth to a mere thirty-seven bedrooms, six dungeons and a neat and well-tailored garden, complete with rose and lavender gardens that were so well-clipped that a high street barber would have been proud of them. Indeed, David was as obsessive over the gardens, as he was over his reputation.

David was equally passionate about WWF. So much so, that Ogilvy and Mather asked, no, told, their best brains to work on the WWF account. So, as Creative Director in the Brussels office in the 1980s, I was asked to work on the charity. In fact, if I had not been asked to work on the account I would have been bitterly disappointed and would

The "Senior Management" Ogilvy Training event that took place in North America. I am front row, second from right, silly me.

have volunteered, irrespective of my youthful ignorance of how things worked at the WWF.

Worldwide, Ogilvy and Mather's media departments were procuring pro bono advertising space in influential magazines such as Newsweek, Time, and National Geographic, along with some free, but very limited, airtime on TV.

The WWF was particularly strong in Brussels, the capital of Belgium – a supposedly insignificant country, as one of my friends ignorantly put it, 'only responsible for providing good flat fields for battles and inventing the French Fry'.

There was, and is, a specialist office working to influence the policies and activities of the European Union. Incidentally does the EU do anything other than create policies? And does it actually have many activities? Yes it does; lots of them. Activities to make policies! Usually centered around extracting money from member countries, which means you and me, the tax payers, to make sure that those who make the policies, the politicians, those who were normally out on their ears in their own country's parliamentary elections, are employed along-side the attendant civil servants who together have managed to build a bloated organization now numbering, well actually I don't know how many, as nowhere on their website, "Europa, gateway to the EU," could I find the information.

So, in writing this book I mailed them and I'm still awaiting their reply to their initial automated reply, which was, "Thank you for your e-mail. We expect to respond in three working days on average. For more complex or specific queries, responses may take longer." How complex can it be to get the information on the number of staff at the EU?

What's worse, if they consider a complex question to be 'How many staff do you employ?' how on earth can we expect them to deal with

such issues as the EU butter mountain? Or even know what their budgets are and how they are actually being spent?

What was it that P.J. O'Rourke said; "Giving money and power to government is like giving whisky and car keys to teenage boys."

However, what I did find in my hunt for the number of employees was their enlightening box of A-Z of information. I started at A and made my way down the list to Y. There was no 'Z'. On 'A' I found 'About the EU'; on 'E' I found 'Earth Observation'. Then on 'M' I found the mysterious 'Maladministration complaints' (are there many?) then to 'W' where I found 'WTO Issues' and finally to 'Y' where I found 'Youth Policies'. As there was nothing listed under 'Z', may I suggest 'Zzzzzzzzzzzzzz?' It seems to be a distant untouchable bureaucracy.

Treading the corridors of the EU must be like walking down a road made of the most glutinous of treacle, wearing thick wooly socks hand-knitted by granny. Sticky and slow. However WWF seemed to do it well. Perhaps, because of their connections in those days with HRH the Duke of Edinburgh (then International President of WWF) and the big wigs at Shell Petroleum (also on WWF), they knew how to avoid the general congestion of lobbyists blocking the corridors of power, and how to maneuver in the quiet 'side-streets' better than most?

But, back in the supposedly insignificant offices of Ogilvy and Mather, Belgium, what we had managed to pull-off, which we certainly couldn't have done without the tenacious support of our local client was, something of a coup. A big coup! Free airtime on all TV stations throughout Europe! Let me repeat that: Free. Airtime. In every European country. On every major TV station! The value was incalculable. It was

worth many millions of Euros and billions of lire, if the lire still existed, which of course it doesn't, as the EU stuffed that one up, didn't they?

Our local client was ecstatic.

Now, we were faced with an opportunity and at the same time along came a problem. Actually three problems.

PROBLEM ONE: we didn't have a WWF commercial to put on air. The equivalent of being given the Super bowl, for a year, for free, but with no act to put on the stage.

PROBLEM TWO: the airtime donated to us was even more staggering than we originally thought. It was in slots of anything from 30 seconds to 4 minutes, but the length could not be guaranteed. This was the time when, due to films, documentaries and news programmes running shorter than advertised, 'filler' material was needed. This 'filler' time was donated to WWF and, as a 'filler,' it could be cut off at any moment it was running, depending upon the length of time the channel needed to fill!

PROBLEM THREE: the film, or commercial we were to make, had to be multi-cultural and could not be tailored for each country, in each language. The cost of changing every sound track for every European language would be prohibitive.

However, what we did have was a readily opened treasure chest we could plunder, an enormous amount of WWF owned, professionally shot, archived film footage, from all over the globe, showing the damage and destruction in, and of, our world.

Images of black, belching smoke and bubbling chocolate-coloured caustic industrial waste running freely into our rivers, streams and ponds, causing failing flora and fauna and the consequential ailing of

animal health. The pitiful struggle for survival of the many endangered species. Oiled penguins. Porpoises harpooned 'for fun', or whales harpooned and hauled onto factory ships and, whilst still alive, split open, momentarily colouring the decks crimson red. All this pain and suffering for the food of the 'cultured' tables of Japan. Seals being clubbed to death so that the nouveau riche could parade their prize, now a couture fur-coat, down the streets of New York, Paris, London and yep, Brussels. Oh and Greece. Funny how the Greeks like fur-coats, isn't it? In all that heat.

So, if we could edit this disparate film footage together in a cohesive way we would have, with some good editing skills, some very captivating and moving imagery. What we needed was a universal soundtrack that would drive the edit, engage and draw the viewer into watching the film and therefore understand what was happening globally to our wildlife and to our world. Ideally the soundtrack should be something so mega, so cross-culturally appealing that they couldn't turn way from the 'box' and, even better, if we could make it so perfect, ('If pigs could fly', I thought) then the TV channel might be compelled to run the film for the full four minutes.

At some point my mind turned to Paul McCartney. A perfect fit to be associated with the WWF brand. An avid advocate for animal rights, McCartney stood firmly against the bloodlust seal- bashing in Canada, is a vegetarian, living part of his life on his own eco-friendly farm in Scotland with his then wife, Linda. He was, of course, an opinion leader and a mega star (no longer with the Beatles but with his own band 'Wings', formed in 1971 with another 'once-upon-a-time' wife and singer-songwriter Denny Laine). In 1977, the band's song 'Mull of Kintyre' had become the first single to sell more than two million copies in the UK alone. And he had already written, with Wings, a song for a blockbuster film, the theme for the Bond film, 'Live and Let

Die' which featured a powerful and unforgettable melody. To hear it alongside Morris Binder's opening title sequence for that Bond film is intensely breath taking. George Martin, the former producer for the Beatles, arranged, produced and orchestrated the song. 'Live and Let Die' was the most successful Bond theme up to that time.

I ran the idea of getting McCartney to write the song to accompany the film past our WWF client. He agreed McCartney's values matched exactly with those of WWF. He asked if McCartney would charge us. I replied we couldn't afford it if he did; besides we were going to ask him to 'do it for free'. And as Paul McCartney was one of the wealthiest men in the UK I didn't think he needed the money; he was, as we could see from the organisations that he supported, a very charitable man. If we could get to see him we would brief him on what was happening throughout the world of WWF and let him write the song with no interference from us. I then went onto outline the thought that perhaps the song could then be sold to the public and spreading the word of WWF even further. We debated whether McCartney would want the royalties from the recording or whether he would donate those to WWF. I replied that would be up to McCartney, I just wanted him to do the song. Royalties would be a bonus.

The WWF client said it was going to be big. I should go ahead. I had his full support.

I had already approached Garrett's, one of the best TV commercial film production companies in London, and they agreed to edit the footage and provide all the post-production free of charge.

Now, how do we get Paul McCartney?

I discussed it with one of Garretts' directors.

Should we approach McCartney's agent?

Paul McCartney's values seemed to match those of the WWF. So I began an approach... it opened a can of worms!

Absolutely not. His agent would not want McCartney to do anything for free. A 25% agent's fee of nothing is nothing. McCartney might not want the money, but the agent certainly would!

After some thought, either the director or one other member of Garrett's staff suggested we go round the potential problem via someone he knew quite well, McCartney's chauffeur.

So, I went back to Brussels and put together, with our client, a dossier on WWF, their work, and the threats to the world's wildlife. The beginning of the dossier had a one-page overview of the situation (mindful of the fact busy people don't have time to page through thick documents) and what we would like McCartney to do. The body of the document had a number of photographs that told the story, without the need of a wealth of words. The document was couriered to Garrett's. The chauffer was briefed via the Garrett's member of staff and we waited. Very patiently.

Nothing happened.

We waited.

Nothing happened.

Then, after about three months the phone call came from the Garrett's contact. "The chauffeur has managed to have a word," I clenched my buttocks, "and McCartney wants to do it!" He then added "and the royalties of the records will be donated to WWF too."

I sat at my desk, holding the phone away from my ear and gave a long, deep and extremely satisfying 'phew'. I couldn't believe what I was hearing. The adrenalin rush was enormous, almost matching my sense of relief.

"There's something else…" continued the voice, "…it's the wrong McCartney."

"What do you mean, it's the wrong McCartney?"

"Linda. Linda McCartney. She wants to do it. Somehow, I don't know how, the chauffer mentioned it to her, in passing, and she says she wants to do it."

I didn't know what to say. So, just to fill in time while I thought it through I said, "So, what do you think?"

"What do I think? Well, what do you think?" shot back the reply.

"I think." I paused. "I think that we want Paul McCartney. Not Linda."

Now, in retrospect that was very stupid of me. Very pig-headed of me. What on earth was I thinking? Linda was a member of Wings; she would certainly involve Paul, as he was, apart from being her husband, the band's leader. So, Wings would almost certainly be the band that backed Linda and that would mean Paul would be doing it, anyhow, even if Linda composed the song and sang it solo. But no, in my pig-headedness, I wanted Paul to say yes.

So I continued, "I think we want Paul McCartney. We need to work out how to say no to Linda."

After a pause I added, "And that's what I don't know how to do."

This actually was the least of my worries.

A note arrived from David Ogilvy: 'Stop all work on WWF until you hear from me. D.O.'

Stop all work on WWF until you hear from me.

D.O.

David at this most officious.

It was addressed to me. The 'D.O.' with no signature meant that this was David at his most officious.

What was going on? I called our local client but was unable to reach him.

Then the second note, which arrived a couple of days later, made my heart thump even more. In fact, it seemed to split my heart into two, one half remained where it was, thumping away like a jackhammer, whilst the other half went up my throat and into my head and was banging around inside it whilst my pulse was hammering in my ears.

It read: 'Using a pop star to promote a serious organisation like WWF was guaranteed to make me see red. I am coming to see you. D.O.'

Using a pop star to
promote a serious
organisation like WWF
was guaranteed to
make me see red. I am
coming to see you.

D.O.

Whoops. The 'Holy Spook' was coming to haunt me.

The 'D.O.' felt more like a 'F.O.' to me, although David would never countenance such language.

Eventually I got hold of my client. "What's up?" he said.

It turned out he was so excited by the McCartney idea that he had
mentioned it to a few high-flyers at WWF, and they too were excited, so
in turn had mentioned it to David.

And that is when the shit hit the fan. With the fan aimed directly at me,
by David.

Everyone else was ducking, with good cause.

WWF was David's baby. And David, even though he would later change
his mind, did have clear and heavily entrenched views and rules about
advertising and how it worked. And one of his rules was you don't get
pop stars to make commercials about serious organisations. Fine for
chewing gum. Not the WWF. My, how things have changed with Bob
Geldof and the parade of stars that are used to promote Live Aid!

What David, a man who at that stage was around seventy years of age,
and quite set in his ways, failed to comprehend was that Paul McCartney
was no longer a long-haired hippy youth but a happily married family
man of around forty years of age. He was a man of considerable
standing. Was an 'MBE' (and later knighted, Sir Paul McCartney). A
man who passionately shared the same values as WWF and who had
a massive following, no longer from the teenage idols with no spare
cash in their pockets for WWF but from the all-important forty-plus
target market who we were trying to persuade to donate a little of their
income to WWF.

He also failed to realise that he was, like so many big bosses, surrounded
by sycophants. Those within Ogilvy and Mather, and those within
WWF. Although David professed to hate politics, 'Fire incurable
politicians!' and 'I hate toadies!'; he just didn't recognise it in those that
sadly croaked 'yes, yes,' and 'you're absolutely right, David!' responses
to everything he said. In short, they guarded him from reality. In fact,
I remember having a conversation with Ingerborg 'Borgie' Baton, his

THE WAY OF DAVID

Ogilvy

David was very, very fixed in his ways. Cross the line and...

276. *Paul McCartney And The Holy Spook*

head of typography for thirty-five years, whom David said was, 'an angel and a genius'. Borgie was visiting me in the Brussels office before David's impending arrival. We were having a light lunch out of the office so we could have a real heart-to-heart chat.

We had just got to the inner-workings of the Ogilvy Empire.

"You know David just loves visiting all his offices."

I sipped my wine and smiled, in anticipation of what I felt was coming next.

"He says how good it is to see the top managers and the troops. How he gets a real feeling for what's going on. And how honest and straight everyone is with him."

"What?" I said, with a double-measure of surprise. "You're kidding?" I added, almost spitting out my mouth-full of wine.

Borgie continued, "So, I said to David, 'When you visit the offices you don't think they tell you the truth do you?'"

"Oh yes," he said, quite taken aback. "Of course they do!"

"David, they **DO NOT** tell you what's going on." (**DO NOT** heavily under-lined by her deep Danish accent). "They only tell you want you want to hear!"

She added that David was absolutely convinced that everyone loved him to bits, was very relaxed in his presence, were happy to debate with him (as long as what they were saying was what he wanted to hear).

Borgie ended the conversation with David, by saying to him, very directly, "David, I hear the truth. Not you!"

He was not only non-plussed, but he was actually quite hurt that Borgie could suggest such a thing.

I was encouraged to stick to my guns, for David also preached that he wanted people in Ogilvy and Mather 'who grasped the nettle'. Indeed, he describes the ideal characteristic of an Ogilvy and Mather Senior Manager as someone who has 'guts, grace, charm, honesty, and someone with fire in their belly'.

Well, I'd got most of that. So, I wasn't going to give up.

I reached into a drawer in my desk and withdrew Ogilvy and Mather's 'Little Red Book.' The confidential book that had a list of all the senior people in the Ogilvy and Mather world, their office numbers, as well as their home addresses and spouses' names. I could even get David's home number if I wanted to phone him (or I could even speak to his wife, Herta), but I wasn't going to go there, not at all.

I called the man responsible for WWF liaison in Switzerland and took a deep breath.

"Hi, I want to speak to you about the McCartney-WWF opportunity."

The voice at the other end was jolly and welcoming. "Hello Aubrey. I was expecting your call. You're absolutely right about this McCartney thing. McCartney is right for the brand. It's a fabulous idea. It's got lots of legs. It's ideal for the target market, it'll give WWF a much needed shot in the arm of modernity, a high profile and bring the bucks in." I felt much relieved. At last, here was someone who would speak out loud and back me up. Thank goodness for that.

"So you'll back me then, you'll talk to David? Thanks a million!"

"Absolutely not, Aubrey." His reply shot back like a bullet into my heart.

"I can't back you. Look, you've opened a real can of worms here. WWF

is his pet account. He was one of the founders. Getting McCartney is a really hot idea, but it goes against David's rule, you know, the one about..." and then he changed his voice into that of mimicking a preacher, "...singing is for chewing gum and not for a serious organisation like WWF, and all that stuff."

"But," I insisted, "David is wrong. Terribly wrong!"

"I know he is, but you're not going to win this one. Sorry Aubrey, I wish I could, but I can't help."

Then he hung up. Not abruptly; he probably said something like, 'Good luck', but I didn't really hear what he said.

I called a few other names in the 'book' and when I mentioned 'McCartney' I got the usual:

"Can't help."

"Absolutely not."

Some were 'not in' and others refused to return my calls.

I turned to my client in Brussels.

"Aubrey, you are right. We are right. But I hear from everybody in WWF that David is like a bear with two sore heads. Your people are backing away, and, how do you say in English, 'licking the bottom of David'. They, the old ones that is, some agree with David. They have to. To agree with you would be career limiting. The younger, more enlightened ones agree with you. But David is being very stubborn."

We chatted some more for a moment, in which I heard, "even the top brass at WWF are reticent to confront David."

Finally, adding a sack of salt to the wound, he summed it up simply,

"they are terrified of the man."

I felt like I had been well and truly hung out to dry, and David would soon be giving me the hairdryer treatment: full heat, straight into the face.

And I wasn't wrong.

David arrived by train from Paris, and after the initial staff meeting and greetings we sat down to chat in the Managing Director's office.

I hadn't slept much, and it wasn't because I was staying awake like some five-year old waiting up all night for the arrival of Father Christmas; I was awake because I was awaiting the arrival of David Ogilvy: 'The Holy Spook.' I was awake because I was preparing my defense. 'Look David you are a man in your seventies. You are cosseted by those who surround you. Remember what Borgie said to you, no one tells you the truth. You haven't been out in the real world for years. You don't travel much as you hate flying. So, you don't see much. You are out of touch. Get out of that castle, into the street. Talk to the real forty-year olds. Get with it, man!'

Of course, thank goodness, I told myself on my second night of wide-awake sleeplessness, leave that tack alone. It would work better if you were more objective Aubrey, try something like, 'I understand your concerns, David'. The brief is, let us remind ourselves, to reach the affluent forty-year olds. We need something or someone that can 'engage them' and 'resonate' with them. Someone who they can look up to. Someone who shares the same brand values as WWF...' and then my mind wandered back to 'Paul McCartney has all these values. David, talk to the people in the street...'

So, there we sat in the Managing Director's office. David was drinking tea and smoking our cigarettes, Dunhill tipped. He never had his own (he usually smoked a pipe anyway) and never carried any money ('A true

Scot,' said someone, 'short arms and barbed-wire in his pockets').

After about fifteen minutes of pleasantries, during which we were circling each other like wrestlers in the ring, David opened the conversational bout.

"You were guaranteed to make me see red."

I fought back, "David I understand your concerns…"

He then butted in, "I will not have a drug addict selling the WWF."

"David, Paul McCartney…"

"Aubrey, let this be an end to it."

And that was the end of it. A few days later I was told to resign. I should work my notice and leave.

Still reeling from the Holy Spook's lack of willingness to debate (probably due to the fact he had consulted the sycophantic ones), and his ultimate power of, metaphorically speaking, 'sending one shamefully to the guillotine,' I received the ultimate insult.

"Is that Aubrey Malden?"

It was a phone call. A man with an Australian accent was on the end of the line.

"I am Paul McCartney's manager."

Hey! Buoyed-up I thought there might be some small glimmer of hope on the horizon of gloom. Could I go back to David with news, compelling news?

The Australian voice continued, "I understand you want Paul to do this thing for WWF?"

Metaphorically speaking the 'Holy Spook' sent me to the guillotine. Ouch!

David Ogilvy. I made him see red.

"Yes." I said expectantly.

"Fuck off."

"Oh." Out came my stumbling remark.

"Yes. Fuck off. Fuck off. Paul has only done one piece of commercial music and that was for that Bond thing, 'Live and Let Die.' He's not doing any more." He said 'that Bond thing' with some considerable distaste in his voice, and then he continued, "He's not doing anymore. Do you understand?"

I understood, what he was saying, or the inference, 'Don't try any way to get Paul McCartney to do something for free, so I can't earn my forty percent commission (or whatever Paul McCartney pays his manager in commission).'

'Forty percent of nothing, is nothing,' I thought.

"Fuck off." Then the phone went down.

Some years later, when the wounds of being guillotined by David healed, I read that David had great faith in those people who say they can read people's character from their handwriting (graphologists, I think they call themselves). According to them, David's handwriting revealed he was 'impulsive, unpredictable, intolerant, assertive. Tough and tormented'.

He certainly was.

Those graphologists also went on to say he was also 'sensitive and benevolent' which I didn't see until some years later when he wrote to me from Touffou:

Dear Aubrey,

If you are ever in this part of the world, come to dine and to sleep.

I would like to see you.

Yours sincerely,
David Ogilvy